The Art of
MOVING PICTURE POSTERS

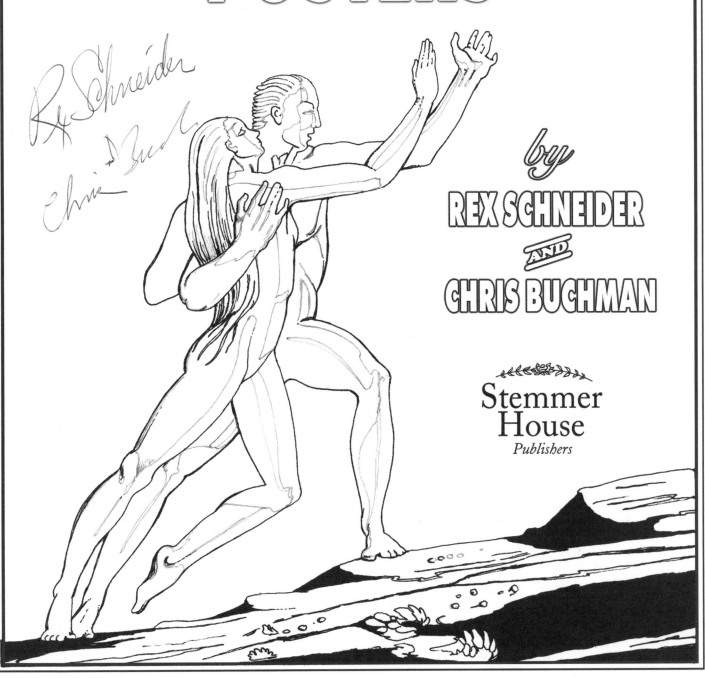

by

REX SCHNEIDER
AND
CHRIS BUCHMAN

Stemmer
House
Publishers

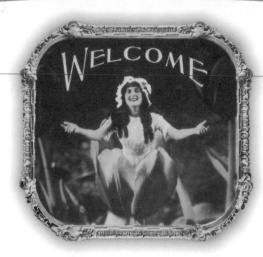

Thrilling Adventures! Madcap Funnies! Magical Phantasies! Exotic Romances! Merrie Musical Masquerades! The Movies did it all!

The colorfully-inviting posters exploited the themes as much as the art and popular culture of the times.

The earliest film posters in America and Europe *(1895 - 1915)* reflected traditional motifs of Music Hall, circus, legitimate theatre, and even Lautrecian lithographs, as with *Cinématographe Lumiér, Phono-Cinéma-Théatre* and *A Keystone Comedy.*

Art Nouveau grew out of the aesthetic movement of the 1880s by such novel illustrators as Alphonse Mucha and Aubrey Beardsley, its delicate, swirling lines lending agreeably to cinema posters for *Afgrunden, The Price Of Silence,* and *Salome* - after Beardsley's illustrations for the book of the Oscar Wilde play.

The poster for *Cleopatra,* fusing intricate lines of nouveau with the geometric motifs of ancient Egyptian antiquities, can be said to be a precursor of the modern Art Deco movement of the 1920s, exemplified by the aesthetics of machinery depicted in *Metropolis,* and the *decor*ative Americana of *Whoopee.*

Expressionism - which evolved around 1915, raised the expression of emotions above depiction of objective reality. The style remained in the post World War One film industry in its darker, more sinister, form beginning with *The Cabinet Of Dr. Caligari* in 1919. Its surreal qualities endured well into the talkies creating the perfect, foreboding, atmosphere for *Murders In The Rue Morgue* in 1932.

Art Directors developing screen adaptations of Faerie Tales frequently drew inspiration from the imaginative works of such grand masters of story book illustrations as Arthur Rackham and Edmund Dulac. Anton Grot, in creating the visual concept for Doug Fairbanks' *Thief Of Bagdad* (as well as the poster) went so far as to duplicate an extraordinary tableau by Thomas Mackenzie from the artist's magical vision of *Aladdin & His Wonderful Lamp.*

The colorful, eye-catching, action-filled illustrations that adorned the covers of pulp-fiction novels and rags of the 1920s and 1930s, touting amazing adventures, tales of robots and racketeers, shoot 'em ups, and cliff-hanging yarns, became the style of art that proved a success in promoting similar screen fare from *The Adventures Of Tarzan* and *The Great K & A Train Robbery* to *The Black Book.*

Caricaturing famous film folk, capturing the very essence of their personalities is an art form unto itself. The art of caricature cannot be taught; artists either have the ability or they don't. French artist, Auglemarie, possessed the gift as did Hap Hadley, and Al Hirschfeld. Auglemarie's likeness of *Charlot* is remarkable, as is Hap Hadley's countenances of deadpan comedian, Buster Keaton *(The General)*, and eye-popping musical-comedy star, Eddie Cantor *(Whoopee)*. Al Hirshfeld's expressive portraits of immortal funny fellows Stan Laurel and Oliver Hardy *(Pardon Us)*, The Marx Brothers *(A Day At The Races)*, and Ted Healy & His Stooges *(The Big Idea)*, are unrivaled in their stylistic perfection.

Movie Posters - those colorful and glorious harbingers of pleasures "Coming Soon" to the local Strand, Roxy, and Bijou - have become a people's art form to be enjoyed on their own merits, and to be admired and valued for their aesthetic and historical significance.

ENJOY THE SHOW!

1

SHADOWGRAPHS *1880s*
Pre-cinema illustrated guide for creating *moving picture* shows at home complete with scripts, proscenium, and black cut-out silhouette characters to manipulate against a lighted background.

2

CINEMATOGRAPHE LUMIER *1896 French*
Louis and Auguste Lumiér pioneered the manufacture of motion picture cameras and projectors, and were the first to exhibit movies successfully. Among their filmed vignettes was *A Practical Joke On The Gardner* depicted in this poster for the London premier in 1896.

3

PHONO-CINEMA-THEATRE *1900 French*
The Paris Exposition of 1900 exhibited an engaging program of 'Talking Pictures' - the projected images being synchronized with the sound on various phonographic processes. On the bill were Sarah Bernhardt in scenes from *Hamlet* and a variety of Music Hall artistes.

4

AFGRUNDEN *(The Abyss) 1910 Danish*
Asta Nielsen specialized in tragic roles such as Hamlet. She was the first international star, the most popular actress of 1911, and soon to be the highest paid.

5

A LA CONQUETE DU POLE *1912 French*
George Méliès, former theatrical illusionist, and the movies' first special effects wizard, conjured up hundreds of optical trick phantasies between 1896 and 1912, many hand-colored in a variety of vibrant hues. *Conquest Of The Pole,* his last effort, is based on Jules Verne's *The Sphinx Of The Ice Fields.*

6

HIS MAJESTY, THE SCARCROW OF OZ *1914*
L. Frank Baum, author of the popular *Oz* books, plays and musicals, produced three feature-length films of his celebrated tales. *His Majesty, The Scarcrow of Oz,* full of wonderful magical effects, was the last in the series.

7

A KEYSTONE COMEDY *1914 British*
In 1914 and for many decades to come, the name 'Keystone' meant histrionic hilarity of the first order complete with a climactic chase involving those bumbling beadles of law and disorder, The Keystone Kops.

8

THE PRICE OF SILENCE *1916*
A woman is victimized by the social mores of the day and an evil black-mailing doctor played by Lon Chaney, who would frighten moviegoers a decade later as *The Phantom Of The Opera.*

9

CHARLOT *1917 French*
Portraits of immensely popular film personalities, like Charlie Chaplin and Mabel Normand, were the only inducements necessary to lure patrons into cinemas worldwide.

10

MABEL NORMAND *1917*
As a natural comedienne with a winning smile and a pleasing personality, Mabel Normand was as much loved by moviegoers as was Chaplin.

11

BABES IN THE WOODS *1917*
Enchanting photoplay adapted from the Faerie Tale, *Hansel and Gretel* - one of a series of movies designed especially for children.

12

CLEOPATRA *1917*
Theda Bara was the first film star to be tagged *vamp,* owing to her melodramatic *vampirish* man-devouring screen persona. Miss Bara vamped her way to stardom and was perfectly cast as the seductive Queen Of Egypt.

13

SINKING OF THE LUSITANIA *1918*
Extraordinary animated visualization of the tragic sinking of the Floating Palace, Lusitania, May 7th 1915. Within 18 minutes the sea claimed the ship and 1198 victims. Hand-drawn by Winsor McCay, foremost illustrator of the 20th century and creator of the popular comic strip *Little Nemo In Slumberland.*

14

DAS CABINET DES DR. CALIGARI *1919 Germany*
This poster for the expressionistic *Cabinet Of Dr. Caligari* captures the distorted, nightmarish tale of a carnival mesmerist and his zombie-like somnambulist as told by a lunatic.

15

THE COLD DECK *1920*
William S. Hart's sensitive portrayal of honest, incorruptible cowboy folk made him the movies' first real hero. His pictures were popular with adults and youngsters internationally. A former dramatic stage actor, Hart adopted the middle initial "S" which reputedly stood for Shakespeare.

16

THE ADVENTURES OF TARZAN *1920*
Edgar Rice Burrough's Tarzan stories have been filmed innumerable times. Elmo Lincoln was the first "ape man" in *Tarzan Of The Apes (1918)* and in two later films, of which this 15 Chapter Serial was the last.

17

SALOME *1922*
Oscar Wilde's retelling of the famous biblical legend is one of the most aesthetically-exuberant art films ever conceived, with stylized costumes and sets by Natacha Rambova *(Mrs. Rudolph Valentino)* rendered in black, white, silver and gold, after Aubrey Beardsley's illustrations. Salome was interpreted by Russian actress, Alla Nazimova.

18

NOSFERATU a Symphony of Horror *1922 Germany*
The second screen version of Bram Stoker's novel *Dracula,* featuring Max Schreck as the ratlike vampire, is filled with haunting shadows and foreboding atmosphere. First major success of the brilliant young director Fredrich W. Murnau.

19

LARRY SEMON *portrait circa 1923*
Larry Semon was a giant among his comedic contemporaries. A skillful acrobat, clever writer, and creator of complex sight gags, he rivaled Chaplin and Keaton and got as many laughs.

20

DAS ABENTEUER DES PRINZEN ACHMED *Germany (The Adventures Of Prince Achmed)* Employing the intricate silhouette technique of the Eastern Shadow Theatre, Lotte Reineger and husband Carl Koch produced this remarkable, fully animated version of stories from the *Arabian Nights*. Photographed in an early color process, it remains a singular work of art. Begun in 1923 and completed in 1925.

21

THE THIEF OF BAGDAD *1924*
A thrilling *Arabian Nights* tale featuring the dashing star of youthful exuberance, Douglas Fairbanks. A Spectacular Pageant! Its mythical settings, Mammoth! It's bejeweled costumes, Magnificent! It's stunning special effects, Magical! A feast for the eyes, and a catharsis for the soul.

22

FELIX TRIES TO REST *1924*
Felix The Cat was the first animated cartoon star to gain international prominence under the loving guidance of Otto Messmer who created and animated most of the cartoons.

23

THE PHANTOM OF THE OPERA *1925*
Enduring classic of the macabre with Lon Chaney, master in the art of pantomime and make-up, in the title role. The film's centre piece, among many memorable sequences, is *The Masked Ball,* filmed in Technicolor, in which the Phantom descends the grand marble staircase as *The Red Death*.

24

THE LOST WORLD *1925*
Sir Arthur Conan Doyle's thrilling adventure of prehistoric beasts in the 20th century. The culminating event of a captive brontosaurus terrorizing London became the formula for countless horror films to come. The dinosaurs were created and animated by Willis O'Brien who later breathed life into *King Kong* and *Mighty Joe Young*.

25

SON OF THE SHEIK *1926*
In this exciting sequel to Rudolph Valentino's successful romp of 1921, *The Sheik*, the romantic legend plays father and son. It was the matinee idol lover's last movie. He died within hours of the New York premier to the dismay of millions of sobbing fans.

26

THE GREAT K & A TRAIN ROBBERY *1926*
The legendary star, Tom Mix, who rode with Teddy Roosevelt and his Rough Riders, entered films around 1910. By the mid 1920s he was a larger-than-life cowboy, wore fancy duds, and dare-deviled in scores of *oaters* on his trusty steed, Tony.

27

METROPOLIS *1926 Germany*
The story of conflict between wealthy capitalists who rule a mechanized city of the future, and the robotized workers who tend giant machines far underground, is inconsequential compared to the impressive architecture of strong geometric patterns and the extraordinary special effects of this epic sci-fi masterpiece from director Fritz Lang.

28

MONEY TALKS *1926*
The poster for this prohibition gangster comedy with *deadpan* character actor, Ned Sparks, was created by John Held Jr. whose marvelous illustrations epitomized the era of bootleg hootch and jazz-age babies of the "Roaring Twenties."

29

THE GENERAL *1926*
Buster Keaton's *deadpan* expression, comedic genius, and acrobatic prowess made him one of the 20th century's most creative funnymen. Set in Civil War times, the film abounds in hilarious sight gags and remains among the top ten to this day.

30

LONG FLIV THE KING *1926*
Charley Chase convulsed moviegoers as an average man caught in the middle of a domestic muddle as in this bizarre treasure co-starring Oliver Hardy as a villain.

31

HER WILD OAT *1927*
A rags to riches comedy of mistaken identities starring the sweet and *(not-so)* innocent Irish lass, Colleen Moore, whose fans were legion.

32

GLORIA SWANSON *1928 portrait*
Gloria Swanson was already a legend when this portrait graced the covers of fan magazine. A charismatic beauty, her popularity never waned. Well into the 21st century she is still regarded as the indisputable symbol of the Silver Screen.

33

THE WAGON SHOW *1928*
An accomplished horseman and trick rider, Ken Maynard was a natural for westerns; the prototype of fancy-dress, white-hat, singing cowboys of the 1930s. He was, in fact, one of the first warbling dudes atop his faithful equine companion, Tarzan.

34

THE BLACK BOOK *1929*
The last Pathé silent serial, in ten chapters, features Pathé's premier villain, Paul Panzer. The hero (Walter Miller) and herorine (Allene Ray) inevitably survive *The Flaming Trap*, *The Death Rail*, and *The Fatal Hour*.

35

SYNCOPATION *1929*
Musical hijinks with the lively syncopation of (Fred) Waring's Pennsylvanians, the most popular dance band of the roaring twenties, and a favorite of collegians. *Rah! Rah! Rah!*

36

LAILA *1929 Norwegian*
The entire history of the Norwegian silent film industry is recounted in but 50 films of which less than half survive. *Laila* is the story of an infant saved from the mouths of wolves by a man who raises her as his own. Mona Martenson plays Laila.

37

WHOOPEE *1930*
Lush Technicolored edition of the smash Broadway musical farce starring the multi-talented, saucer-eyed entertainer, Eddie Cantor, with imaginative choreography by Busby Berkeley invigoratingly performed by young lads and lasses of the chorus.

38

PARDON US *1931*
Hilarity in the "Big House" with inmates Stan Laurel and Oliver Hardy convicted of selling beer at the height of prohibition. Simultaneously filmed in German, French and Spanish with the team speaking lines phonetically.

39

A NOUS LA LIBERTE *1931 French*
Old chums, one a successful manufacturer of phonographs, abandon capitalism for freedom of the open road. Man vs. machine musical comedy directed by René Clair; the inspiration for Chaplin's *Modern Times.*

40

MURDERS IN THE RUE MORGUE *1932*
Delicious elaboration of the hair-raising tale by Edgar Allan Poe with a Darwinian charlatan *(Bela Lugosi)* thrown in for good measure. Pre-production poster.

41

A FAREWELL TO ARMS *1932*
Pre-production poster concept for the Hemingway saga as it appears in *Paramount's Publicity Campaign Book of 1931,* but with one exception: it omits the names of leading players, Helen Hayes and Gary Cooper *(herewith added).*

42

BRING 'EM BACK ALIVE *1932*
Offbeat curiosity exploits an expedition of Frank *"Bring 'em back alive"* Buck, to capture wild animals for zoos and circuses. Fascinating, but a sad commentary on the public's acceptance of cruelty to animals for commercial expediency.

43

KING KONG *1933*
Kong is a remarkable work of art; the execution of its three-dimensional model animation; its visual oppulence fusing glass paintings with studio sets and miniatures; and its superb musical score complementing the narrative and punctuating its subtlties. 100% hand-made and far superior to latter day computerizations. There is only one King Kong!

44

SCRAPPY *1934*
The animated misadventures of *"The screen's lovable Mischief Kid."* Scrappy and his pals never failed to please audiences at Saturday matinees.

45

THE BIG IDEA *1934*
Ted Healy & His Stooges: Howard, Fine & Howard, popular vaudeville comics of the late 1920s, appeared together in seven features and five treasured shorts *(1930-1934)* including *The Big Idea.* The greatly neglected Healy was a brilliant scene-stealing ad-libber whose antics never fail to amuse.

46

TIDER SKOLA KOMMA *1936 Swedish*
(Things To Come) The H. G. Wells story was somewhat prophetic: war did come to England and London was nearly destroyed; but war continued well into the 21st century, and in spite of advanced technology, class prejudices boded an uncertain future for humanity. British production starring Raymond Massey.

47

A DAY AT THE RACES *1937*
Marx Brothers madness with Harpo, Chico, Groucho, and their favorite foil, Margaret Dumont. Saddle-silly laughs galore!

48

LE SCHPOUNTZ *1938 French*
Stars Fernandel, whose gentle, compassionate nature and infectious smile won the hearts of moviegoers. In this grand satire from director Marcel Pagnol, Fernandel becomes a successful movie star to the surprise of all who mocked him as a "chump" *(schpountz).*

49

LE VOLEUR DE BAGDAD *1940 French*
(Thief Of Bagdad) Lavish Technicolored *Arabian Nights* spectacle. A magic carpet to romance, mystery and adventure with the youthful Indian actor, Sabu. British production dissimilar to the Doug Fairbanks 1924 edition.

50

The Cockerel trademark of Pathé Frères. Pathé, the oldest motion picture company in existence, was formed in 1896 by Charles Pathé in France.

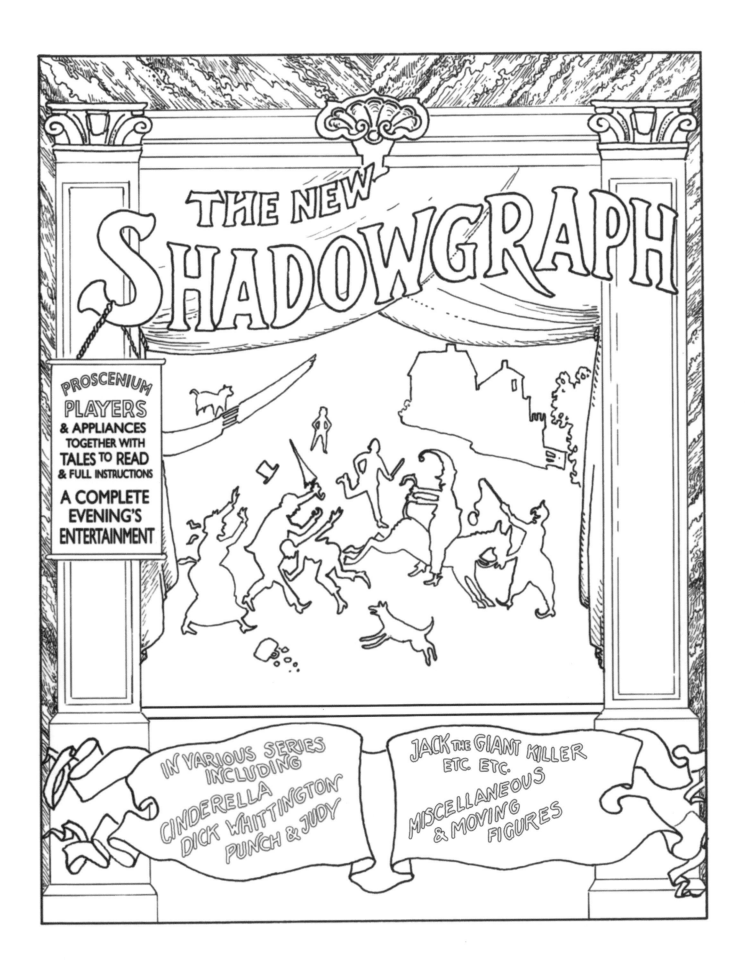

THE NEW
SHADOWGRAPH

PROSCENIUM
PLAYERS
& APPLIANCES
TOGETHER WITH
TALES TO READ
& FULL INSTRUCTIONS

A COMPLETE
EVENING'S
ENTERTAINMENT

IN VARIOUS SERIES
INCLUDING
CINDERELLA
DICK WHITTINGTON
PUNCH & JUDY

JACK THE GIANT KILLER
ETC. ETC.

MISCELLANEOUS
& MOVING
FIGURES

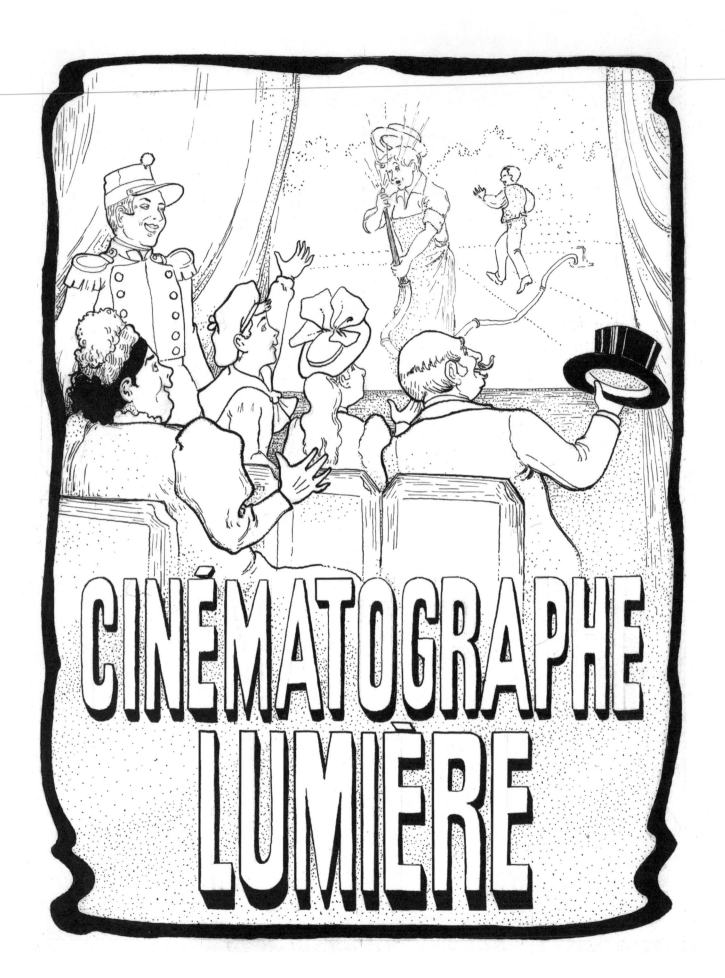

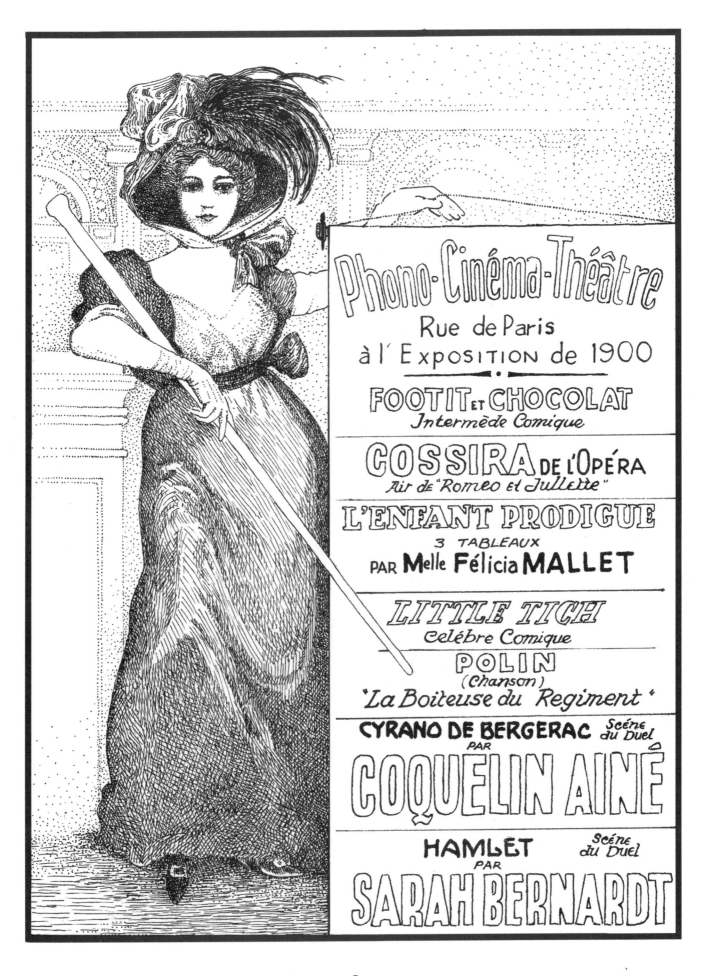

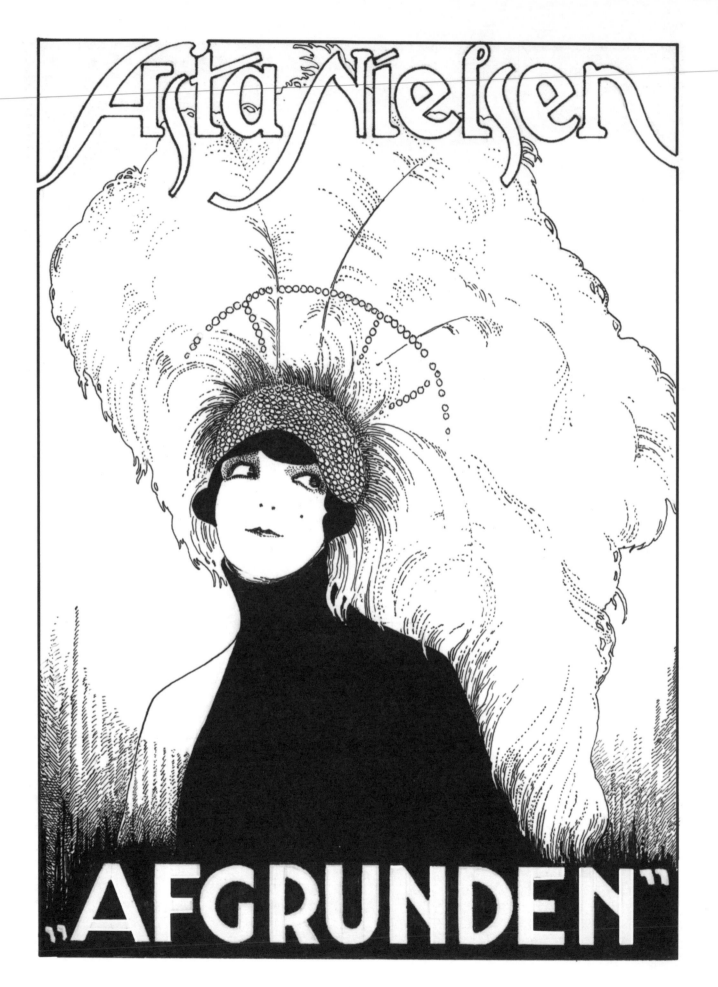

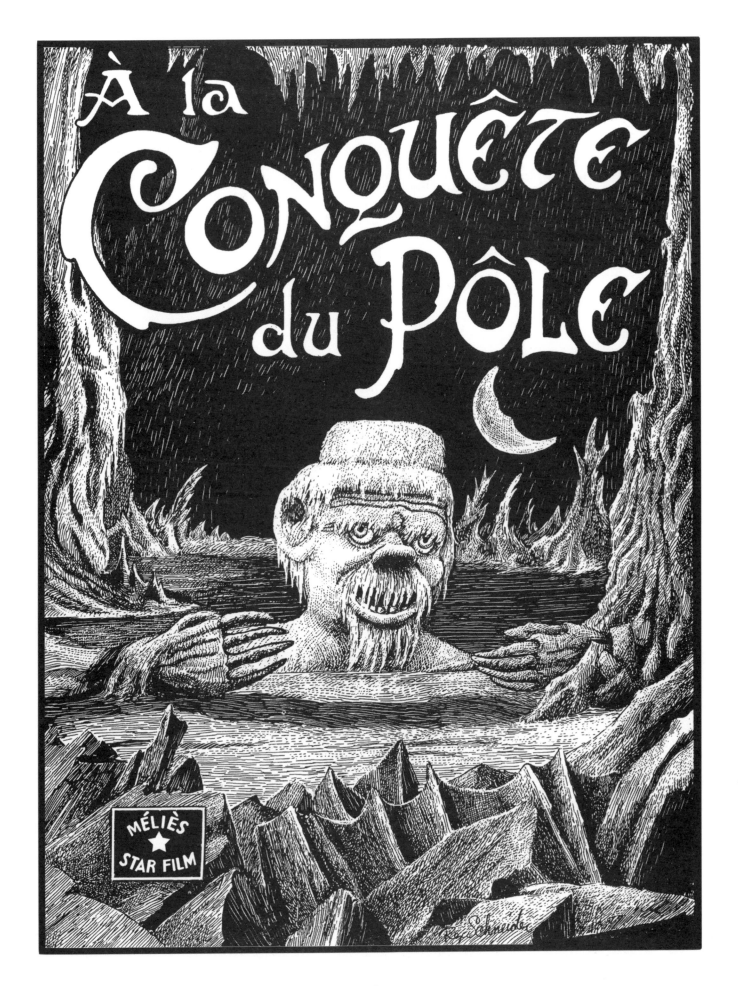

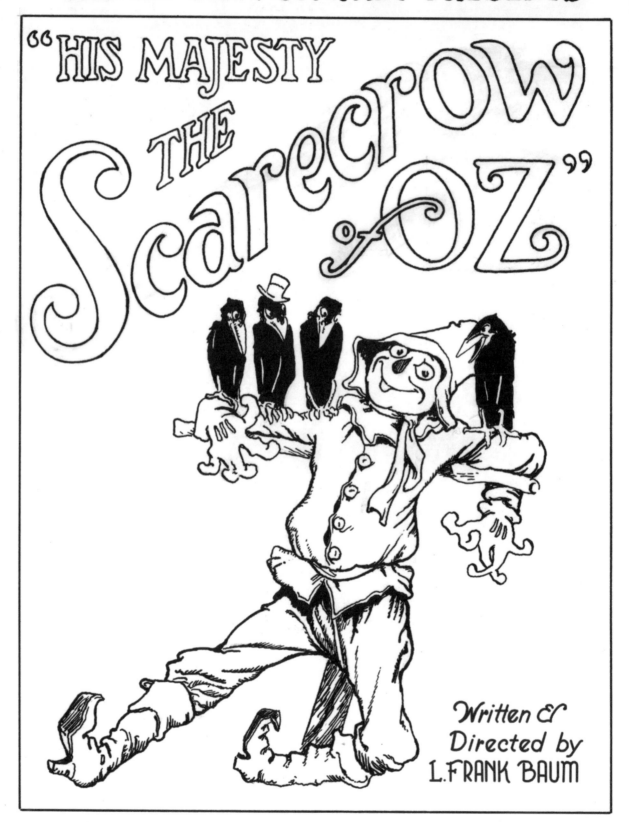

THE OZ FILM COMPANY PRESENTS

"HIS MAJESTY THE Scarecrow of OZ"

Written & Directed by L. FRANK BAUM

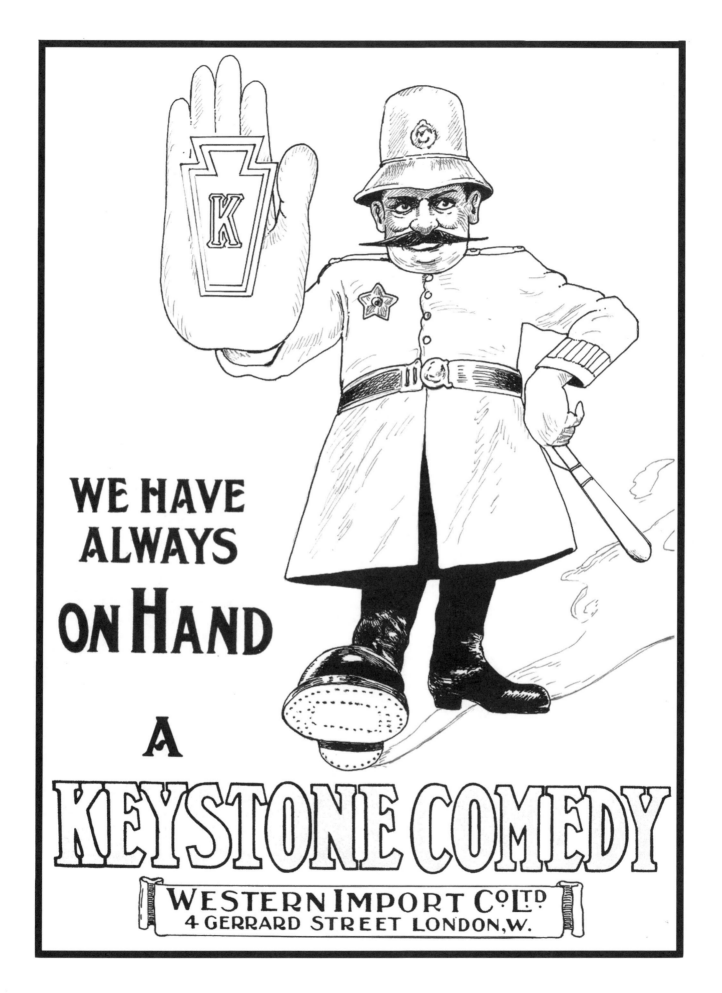

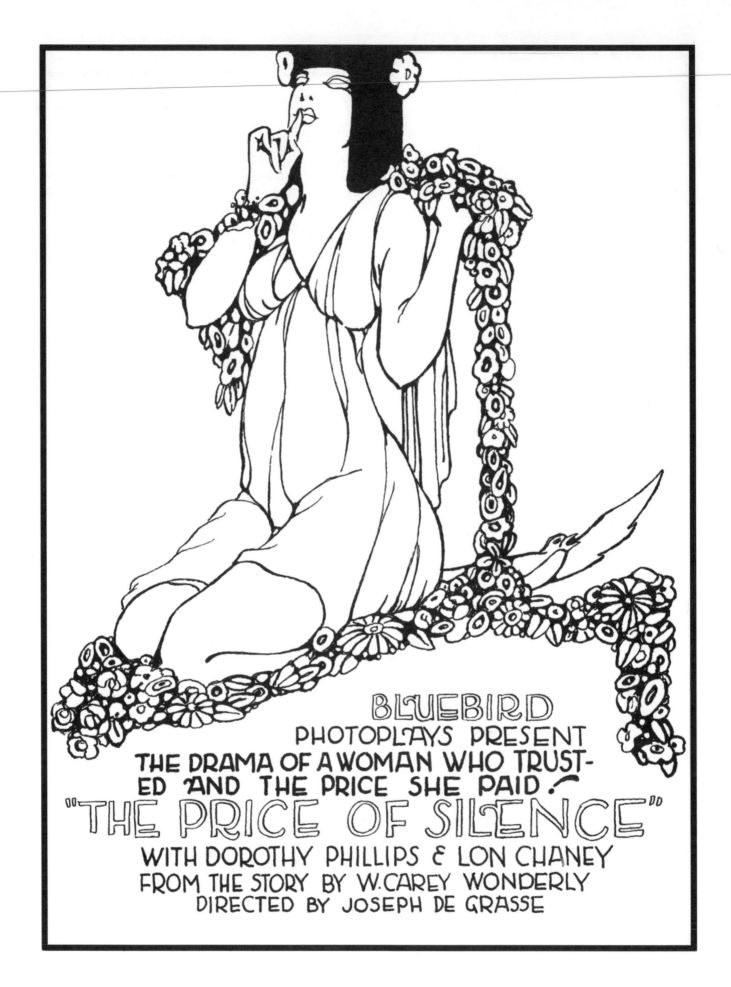

BLUEBIRD
PHOTOPLAYS PRESENT
THE DRAMA OF A WOMAN WHO TRUST-
ED AND THE PRICE SHE PAID!
"THE PRICE OF SILENCE"
WITH DOROTHY PHILLIPS & LON CHANEY
FROM THE STORY BY W. CAREY WONDERLY
DIRECTED BY JOSEPH DE GRASSE

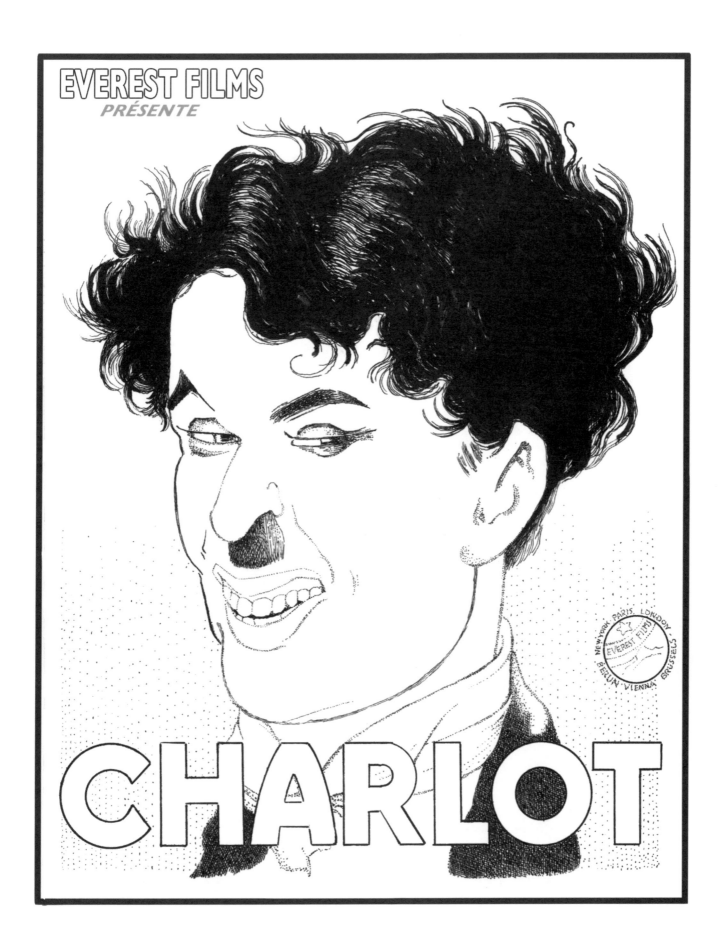

TRIANGLE
KEYSTONE

MABEL NORMAND

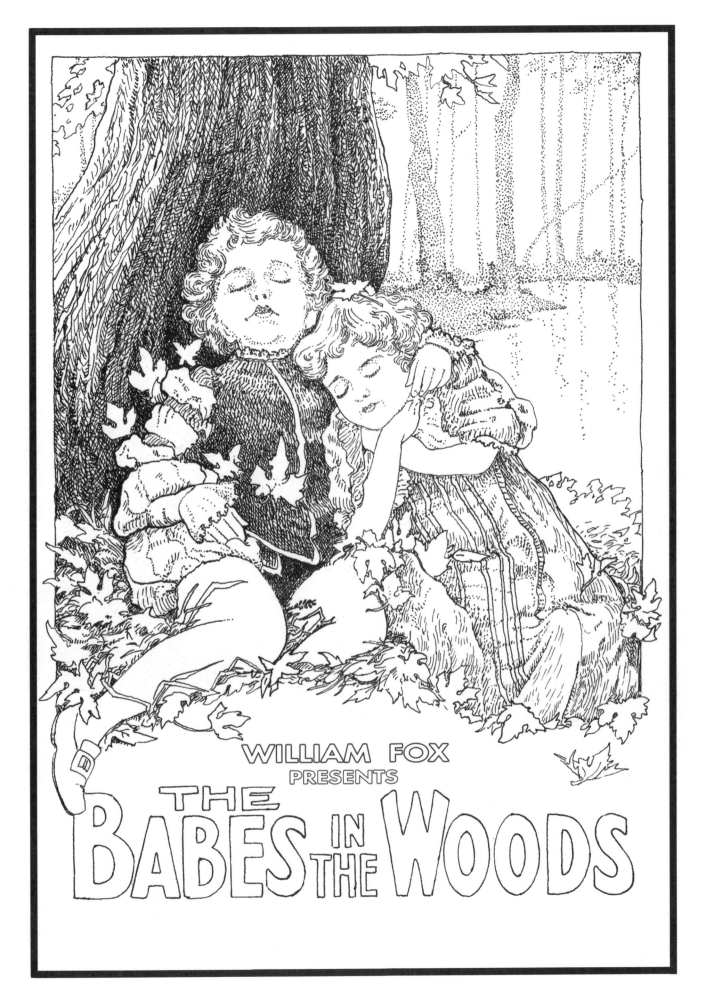

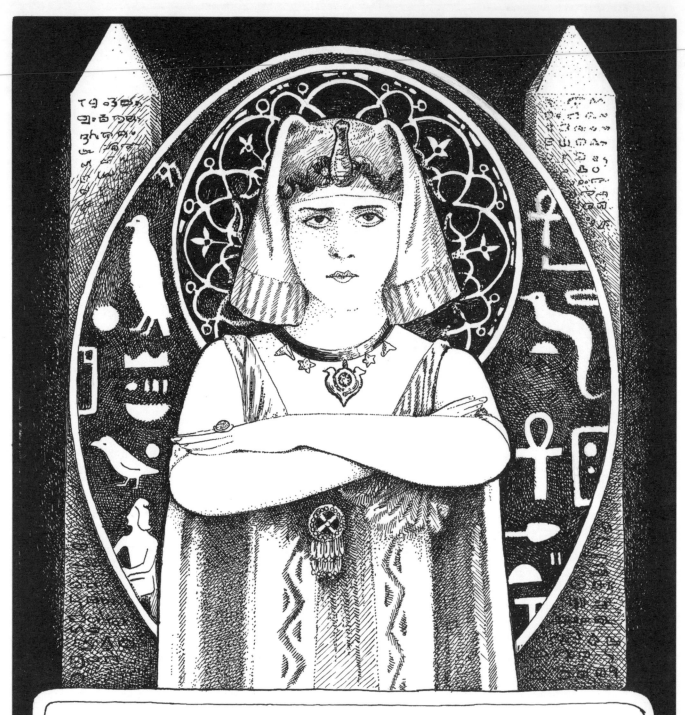

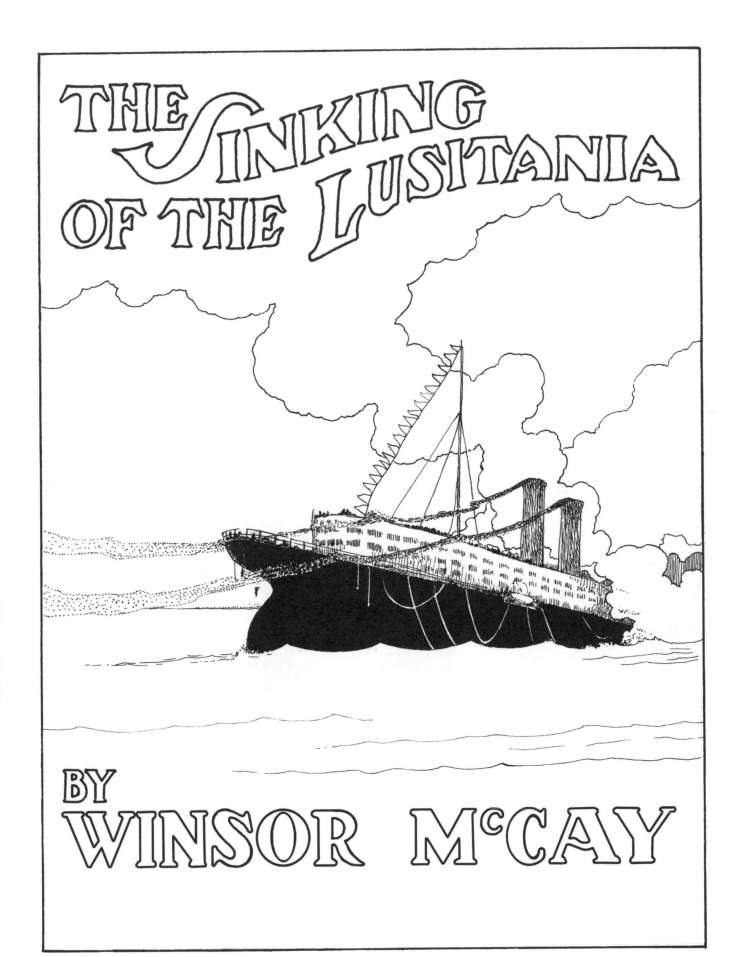

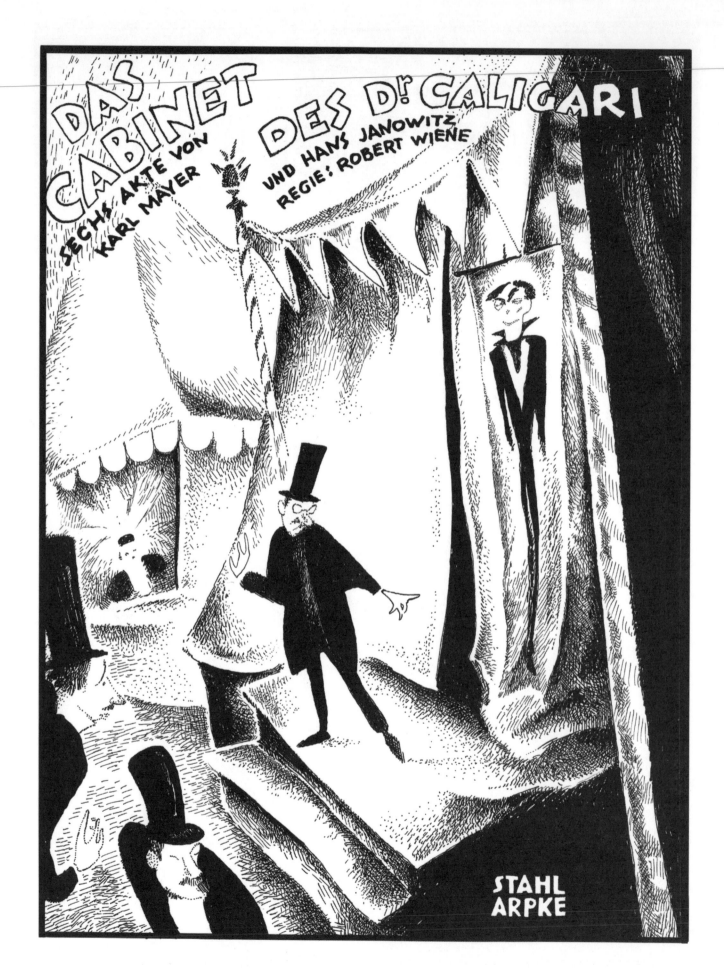

14

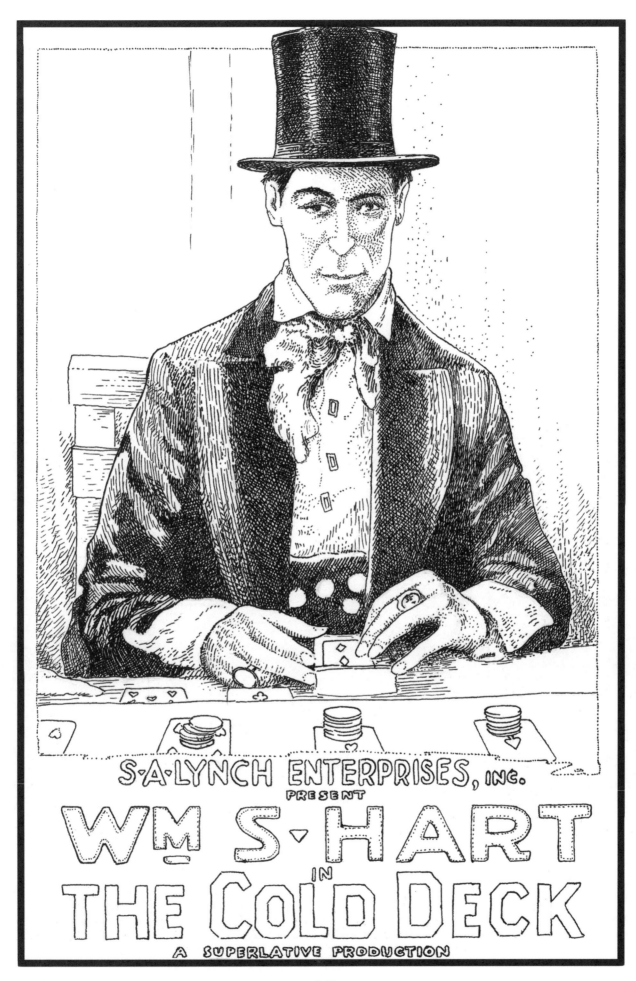

S·A·LYNCH ENTERPRISES, INC.
PRESENT
WM S·HART
IN
THE COLD DECK
A SUPERLATIVE PRODUCTION

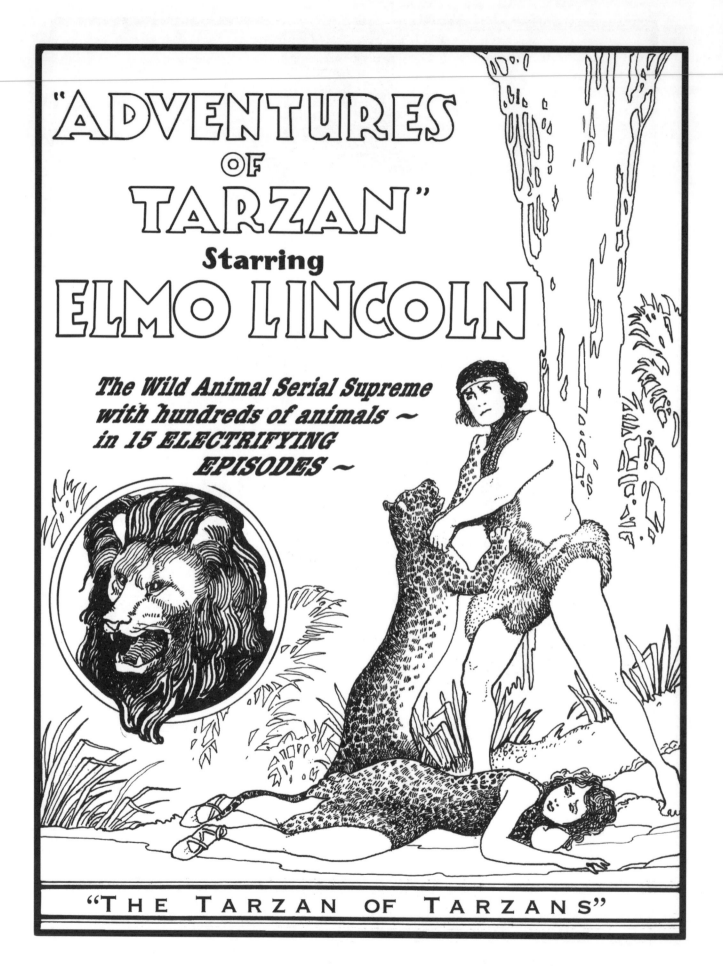

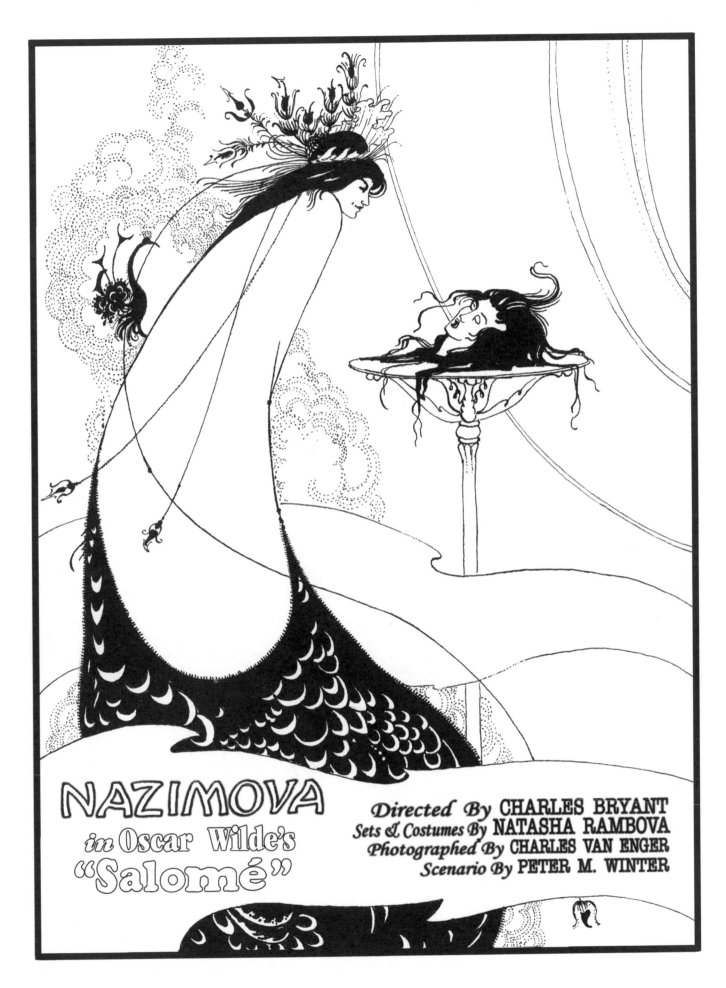

NAZIMOVA

in Oscar Wilde's "Salomé"

Directed By CHARLES BRYANT
Sets & Costumes By NATASHA RAMBOVA
Photographed By CHARLES VAN ENGER
Scenario By PETER M. WINTER

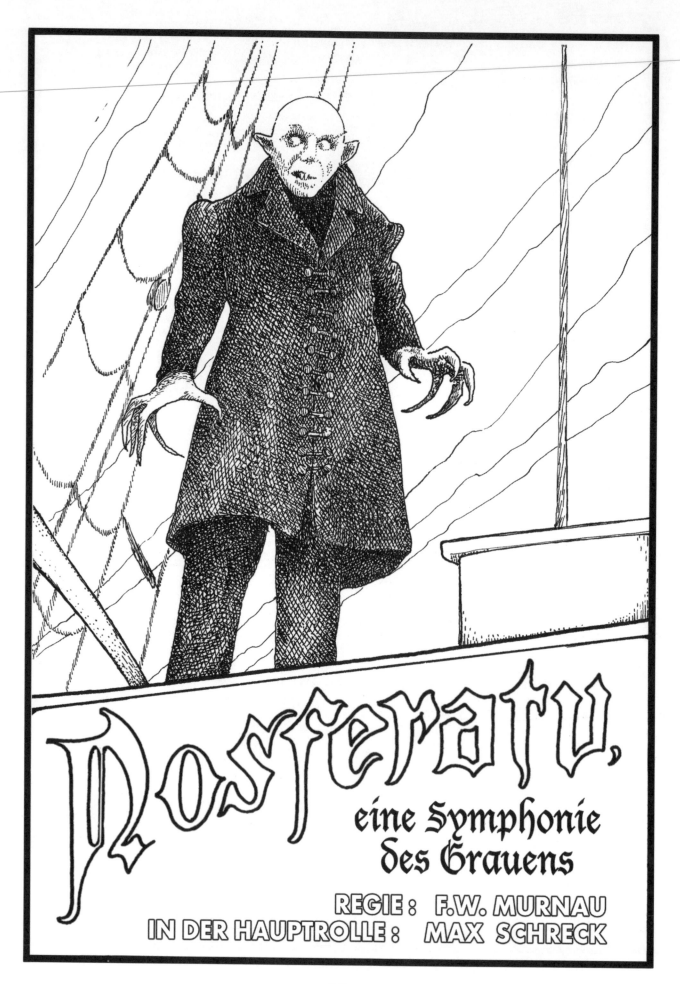

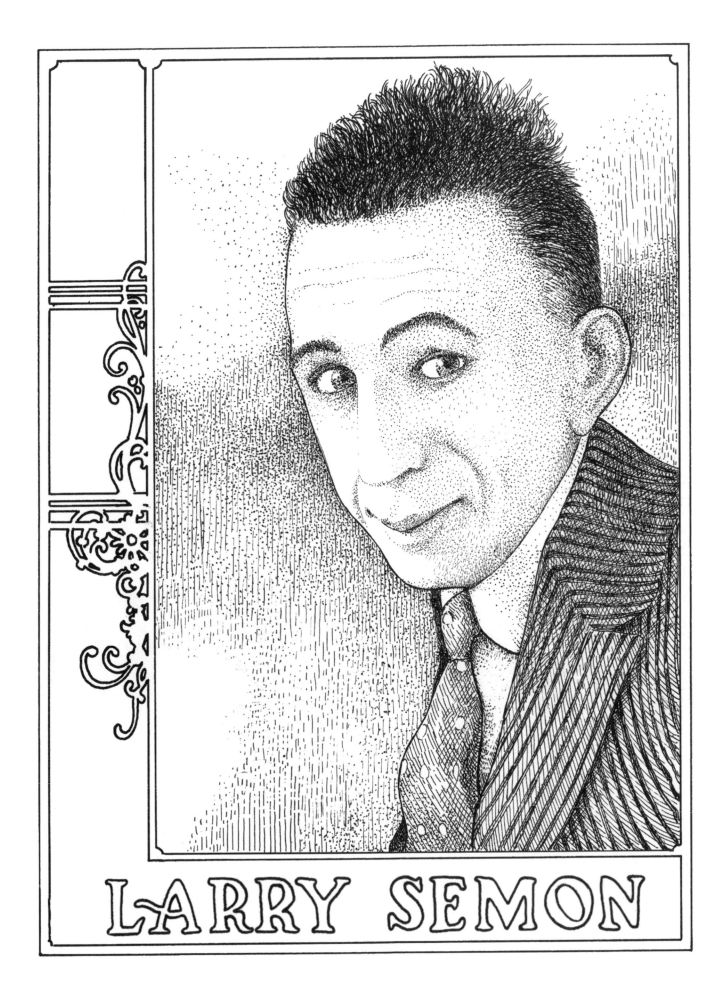

LARRY SEMON

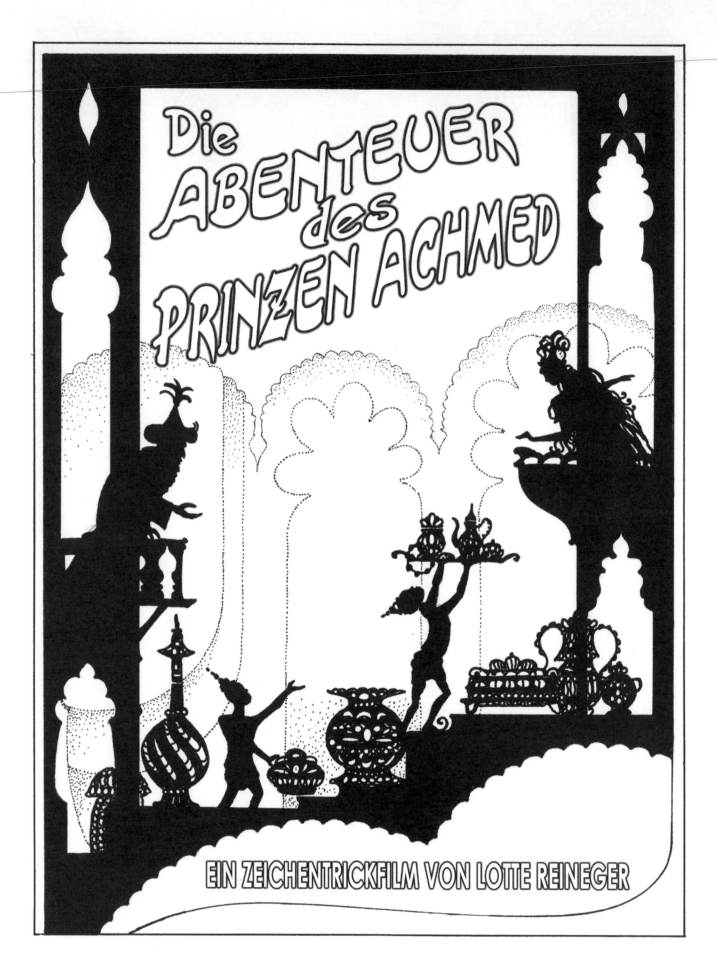

Die ABENTEUER des PRINZEN ACHMED

EIN ZEICHENTRICKFILM VON LOTTE REINEGER

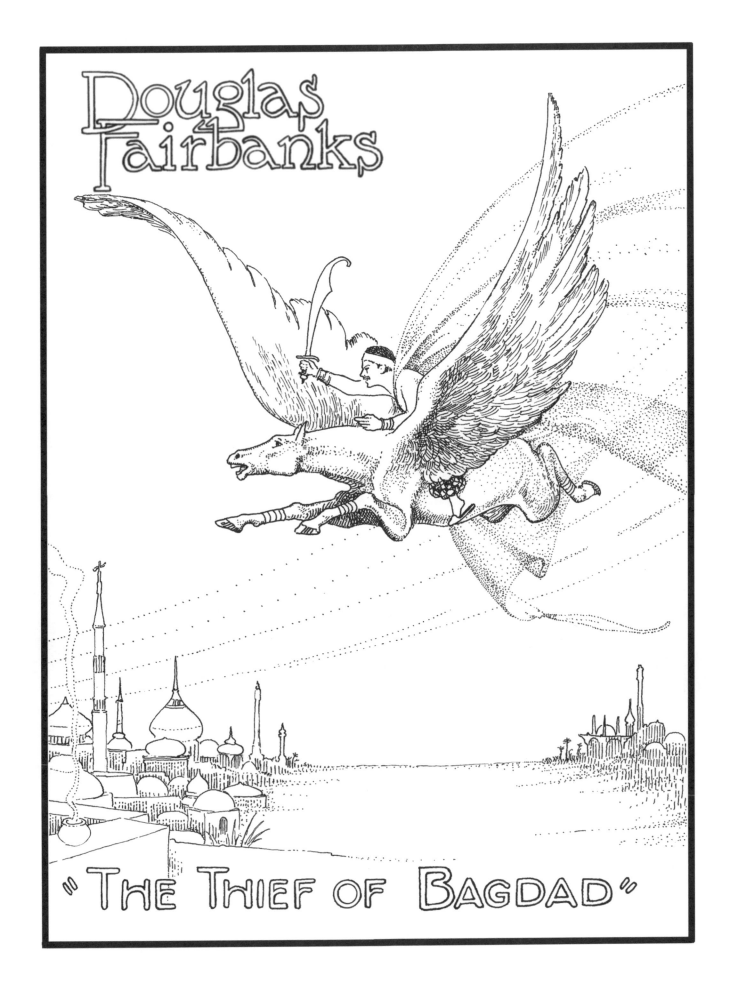

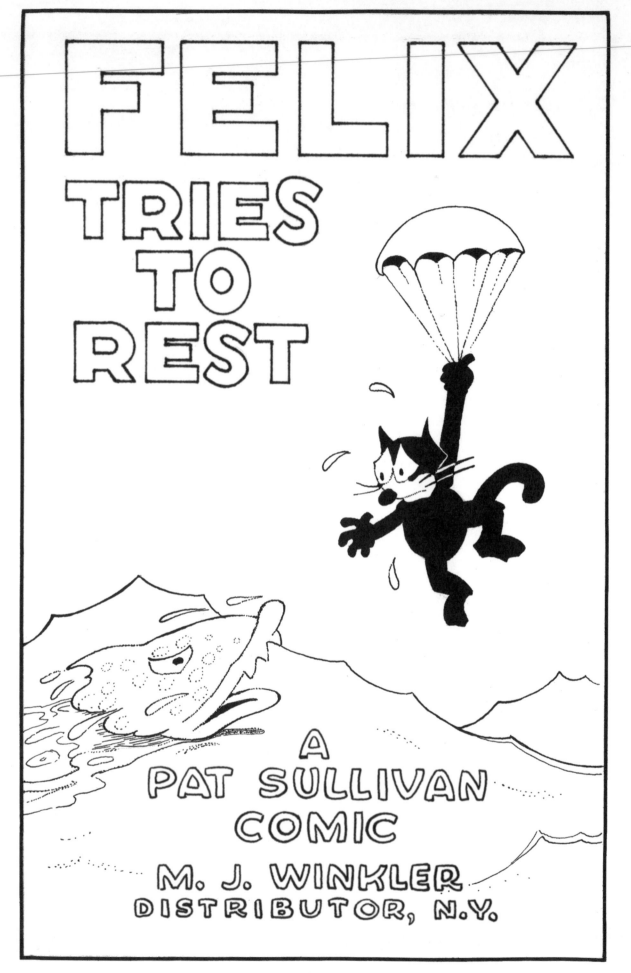

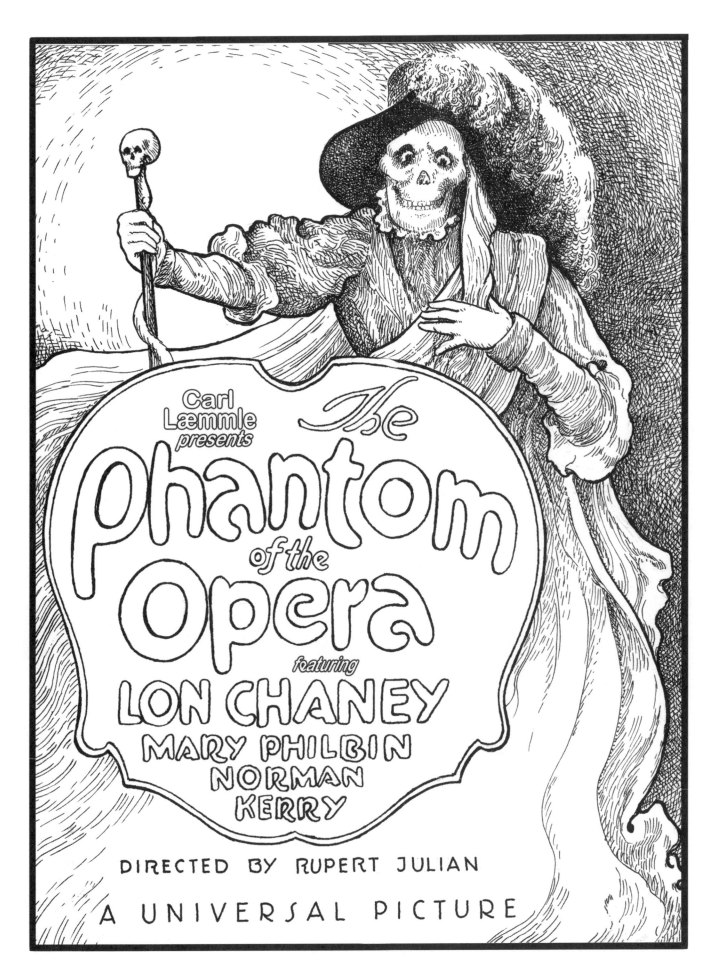

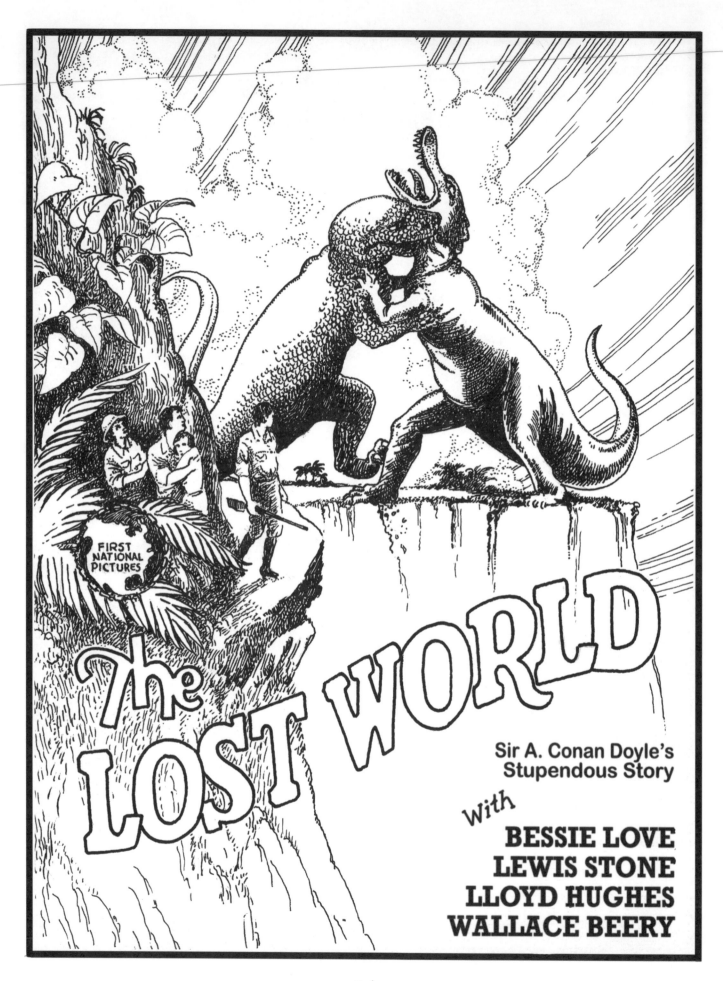

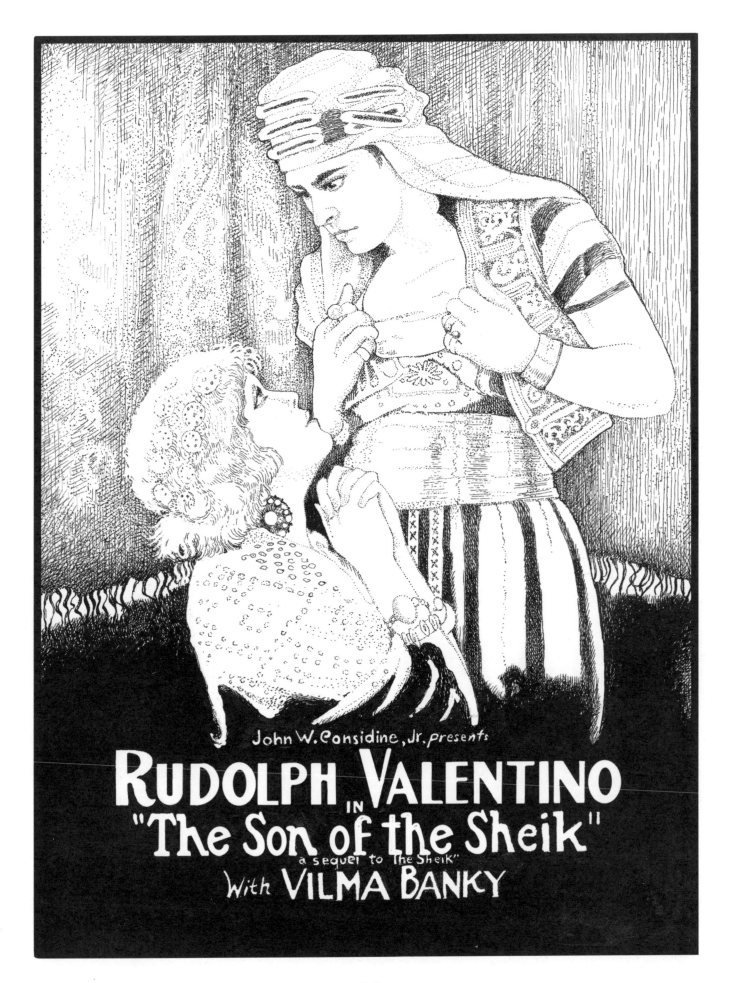

John W. Considine, Jr. presents

RUDOLPH VALENTINO
IN
"The Son of the Sheik"
a sequel to "The Sheik"
WITH VILMA BANKY

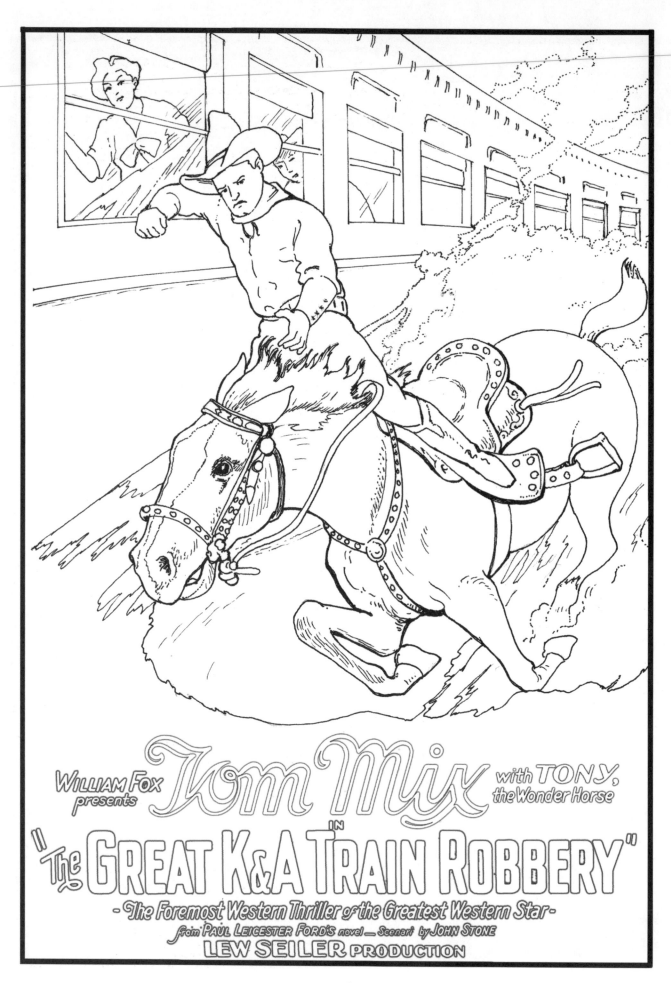

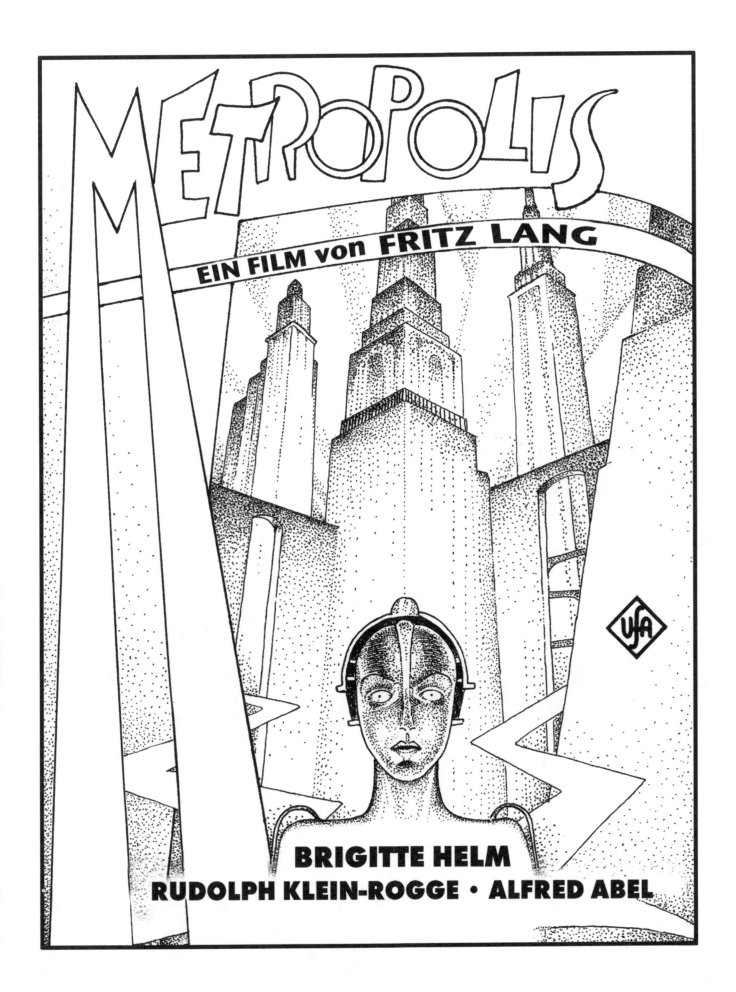

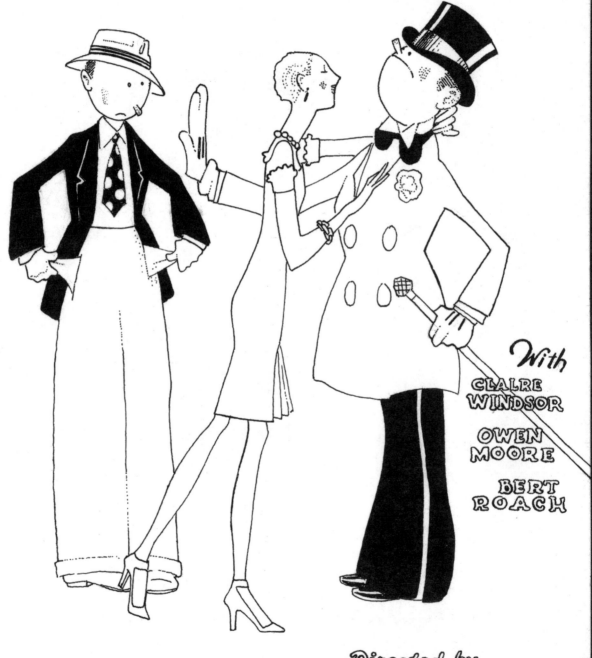

MONEY TALKS

With
CLAIRE WINDSOR
OWEN MOORE
BERT ROACH

Directed by
ARCHIE MAYO

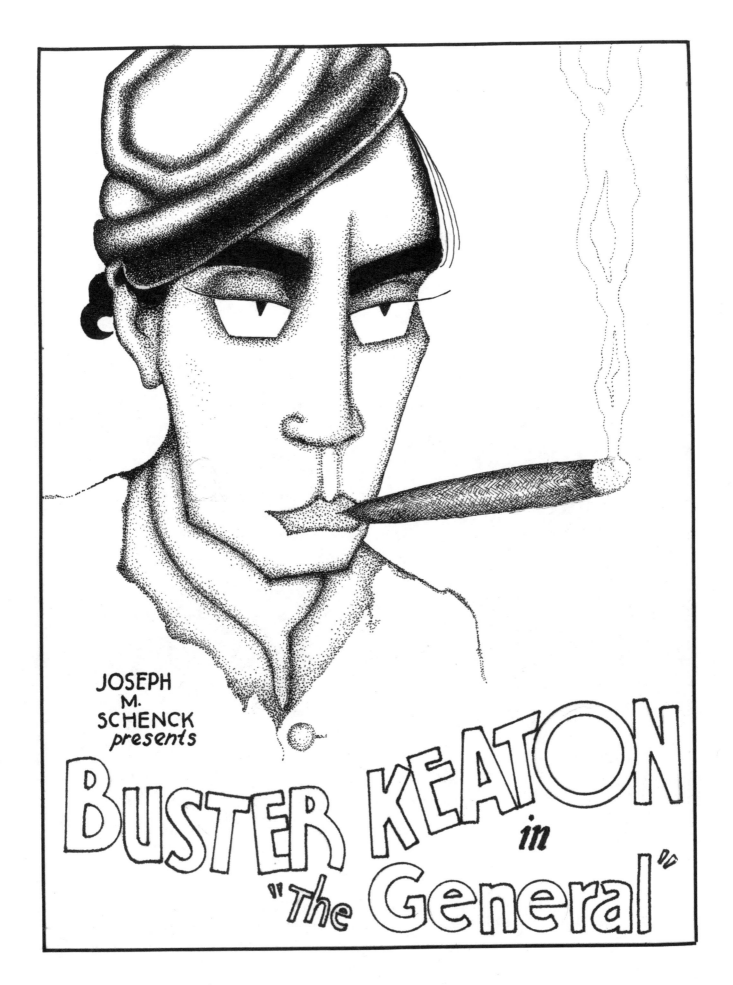

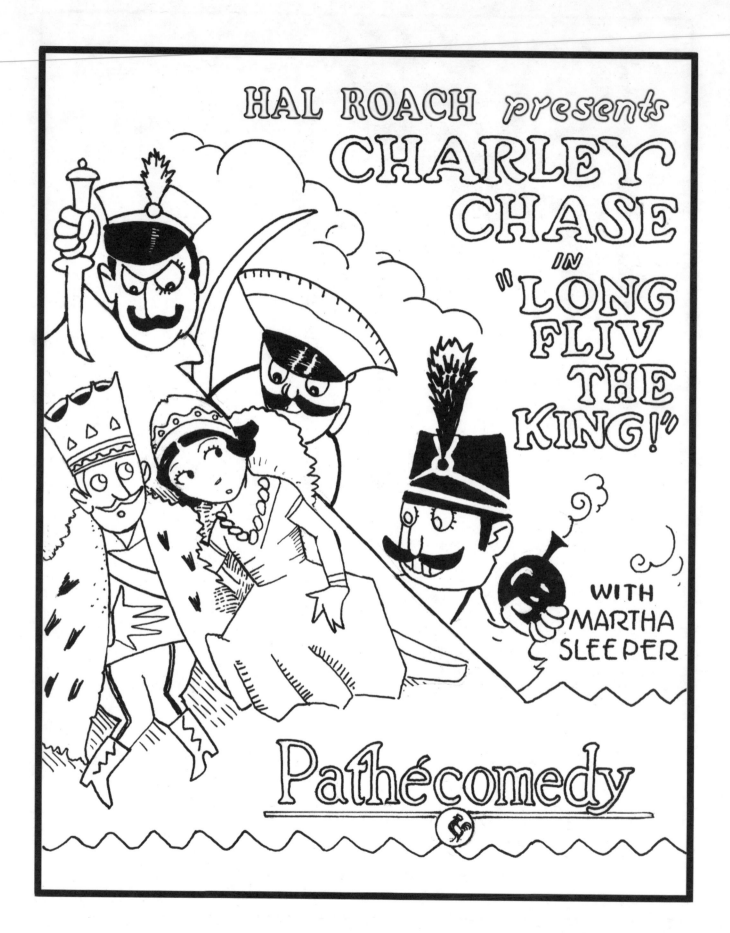

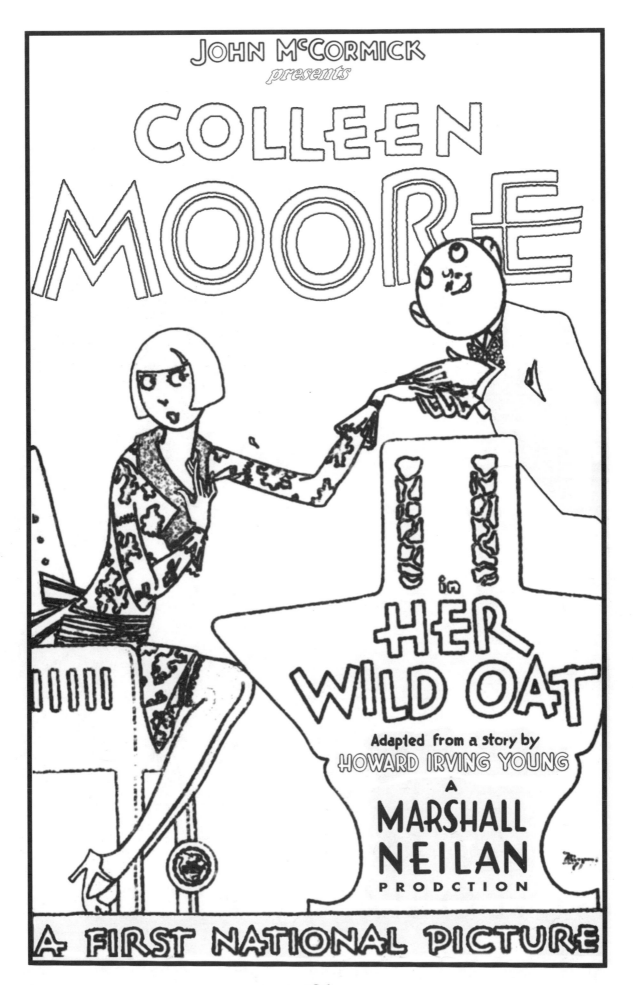

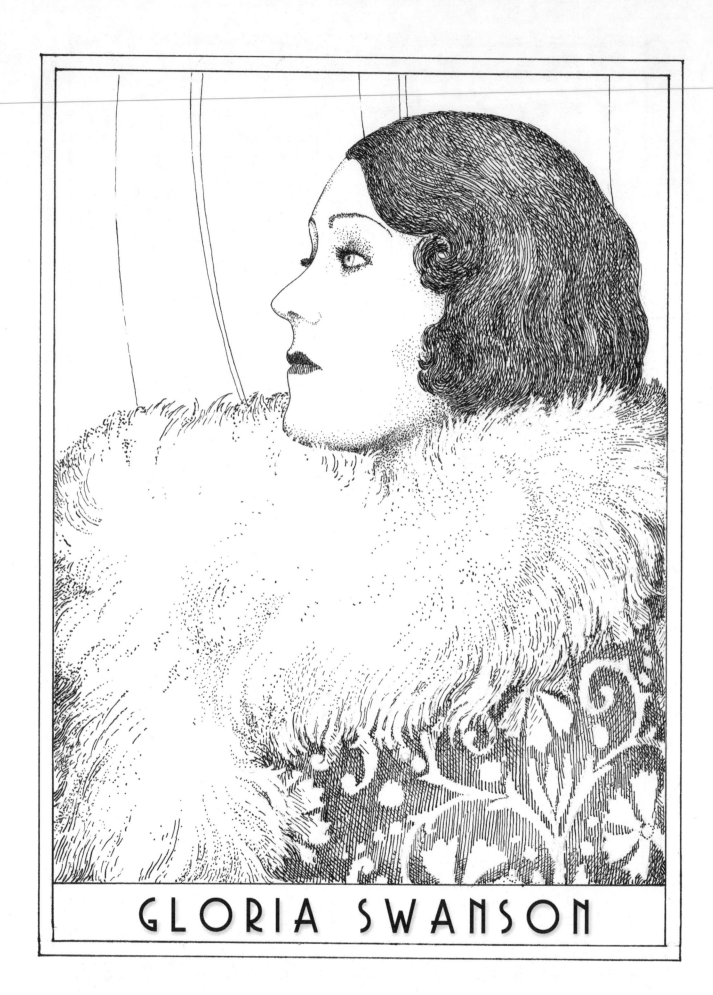

GLORIA SWANSON

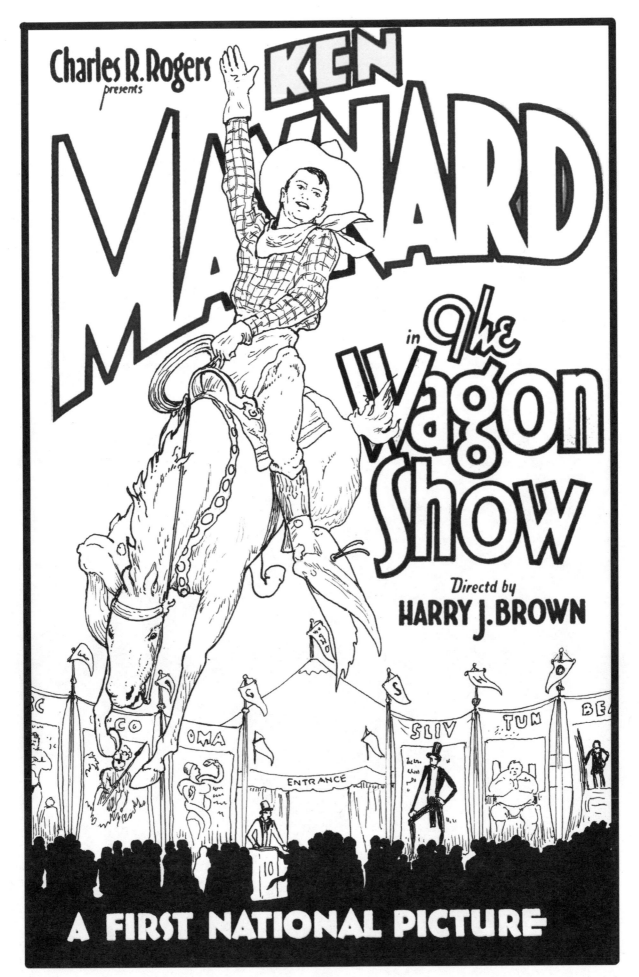

PATHÉ presents
ALLENE RAY and WALTER MILLER

The
BLACK
BOOK

CHAPTER FOUR
The
DANGER
SIGN

BLOOD-CURDLING ACTION!

Pathé Serial

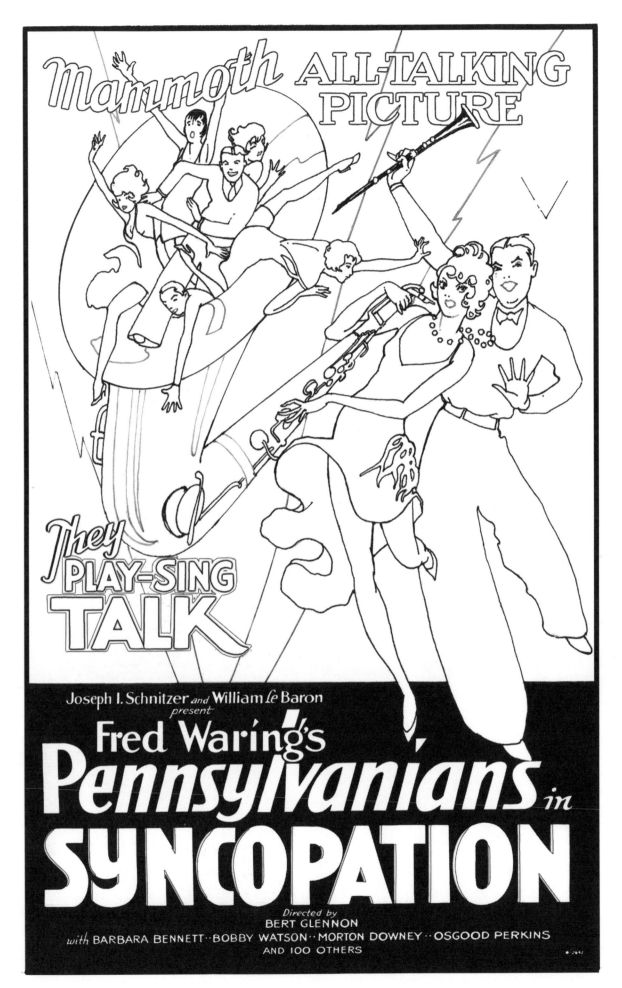

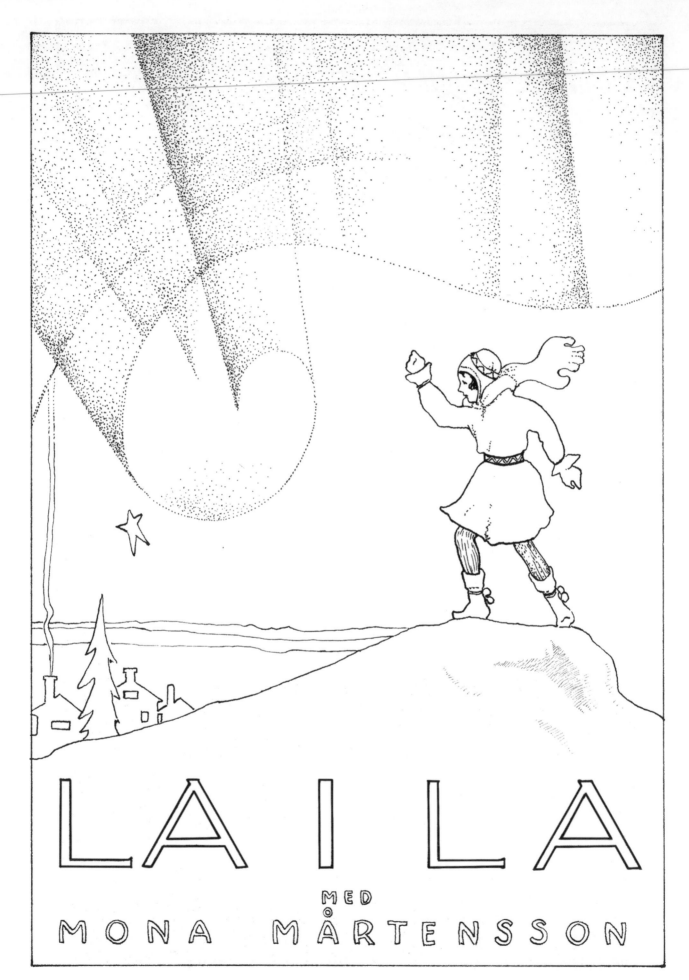

LAILA
MED
MONA MÅRTENSSON

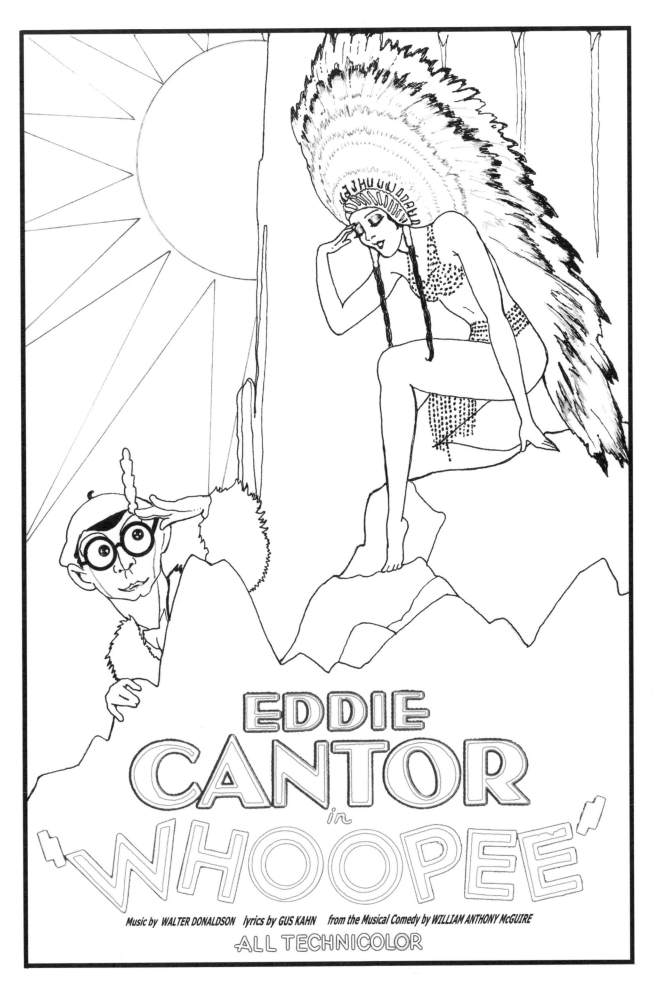

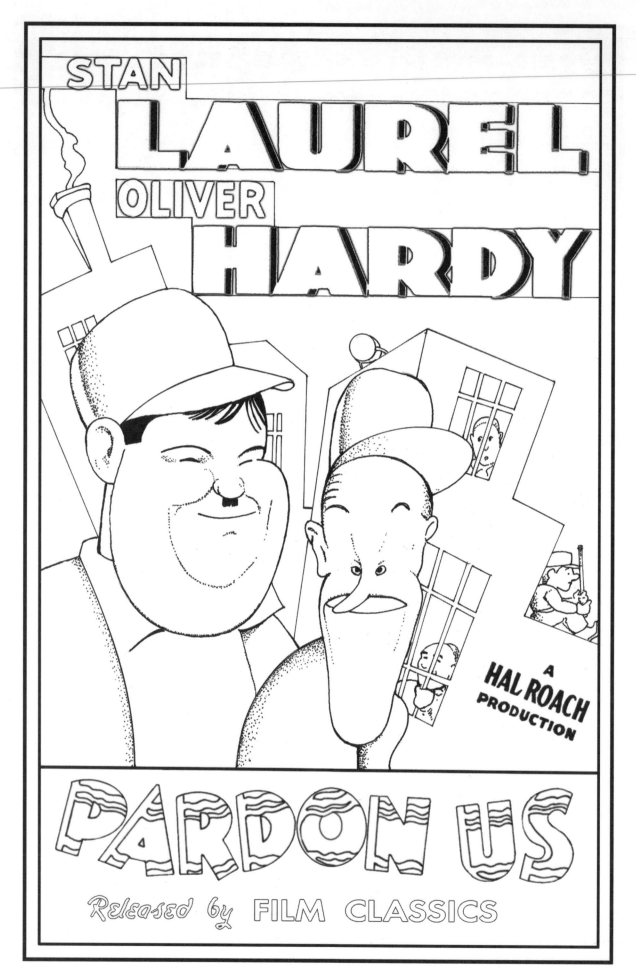

IDEAL THEATRE
903 W. 36th Street
STARTS: WED

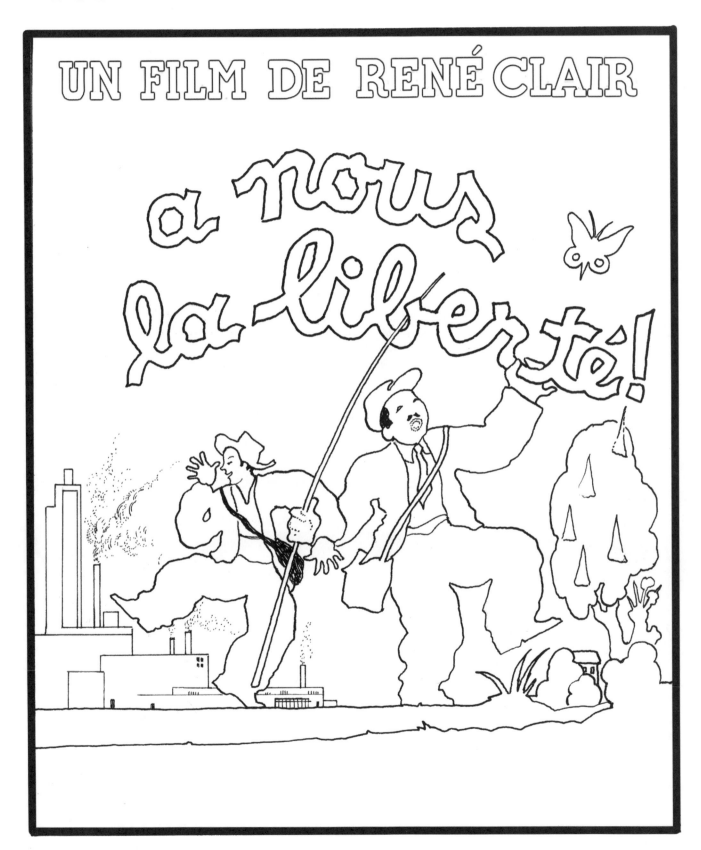

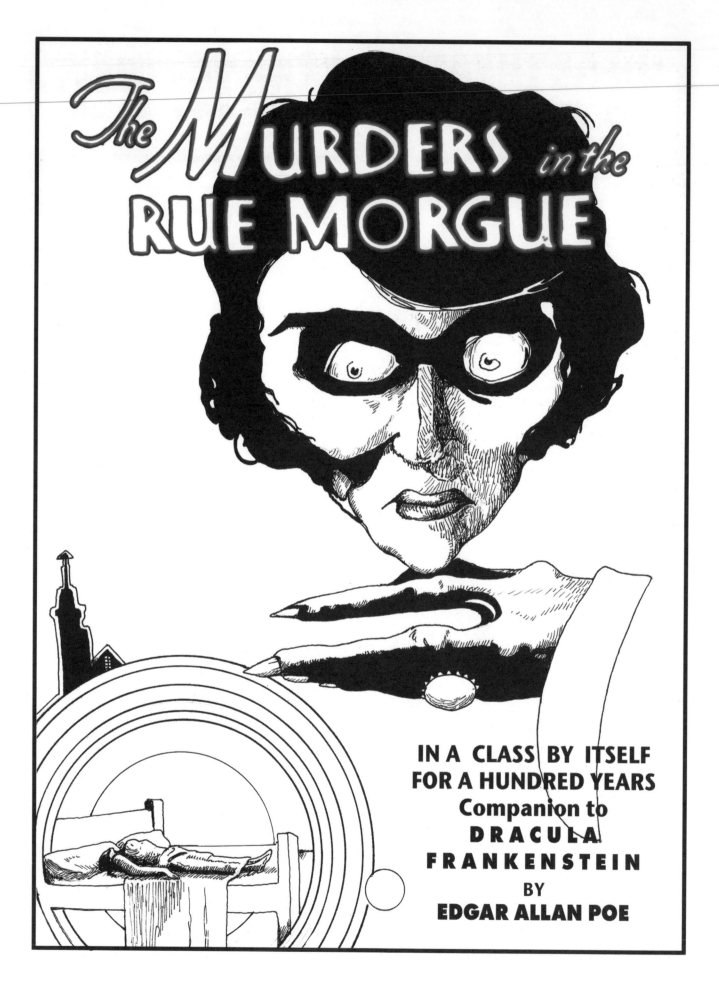

The Murders in the Rue Morgue

IN A CLASS BY ITSELF
FOR A HUNDRED YEARS
Companion to
D R A C U L A
F R A N K E N S T E I N
BY
EDGAR ALLAN POE

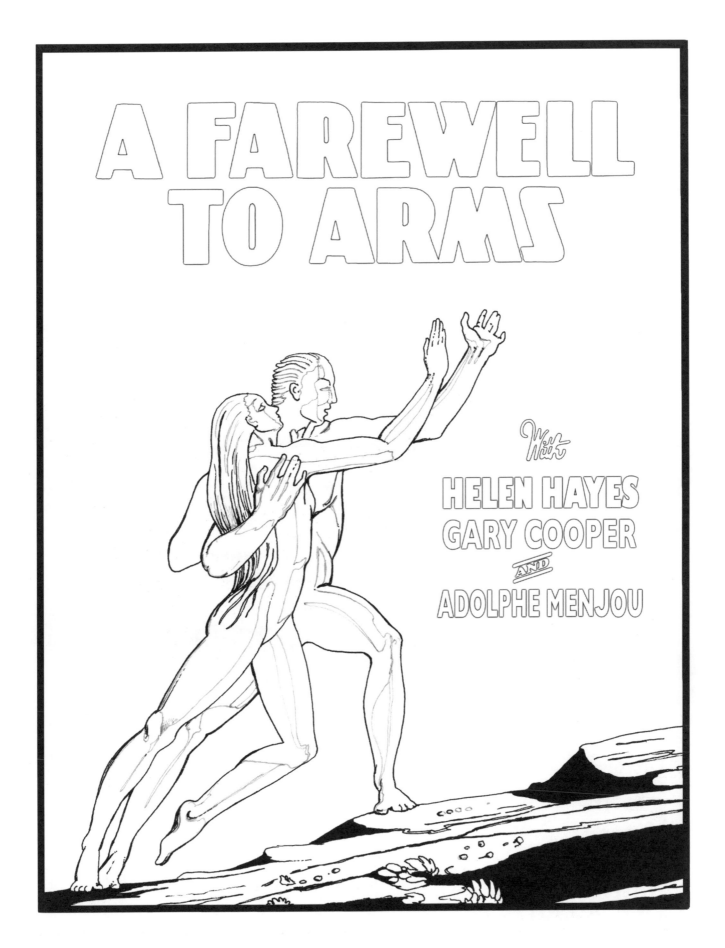

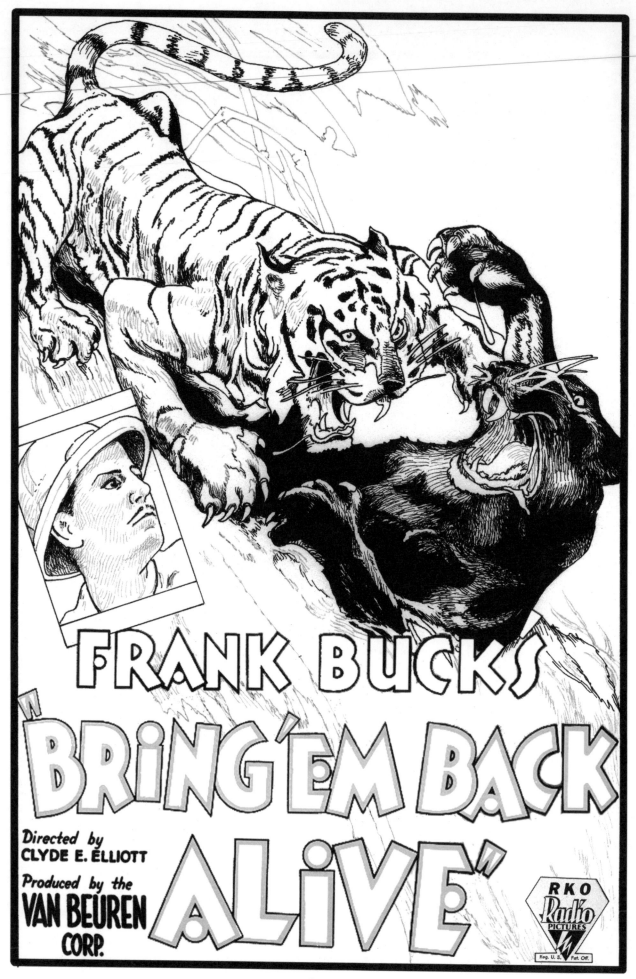

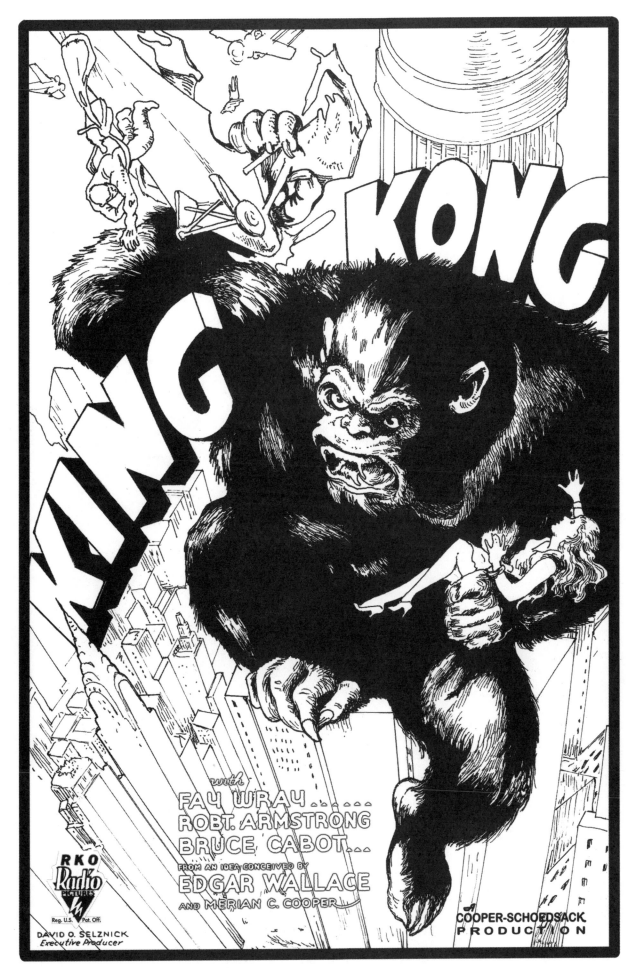

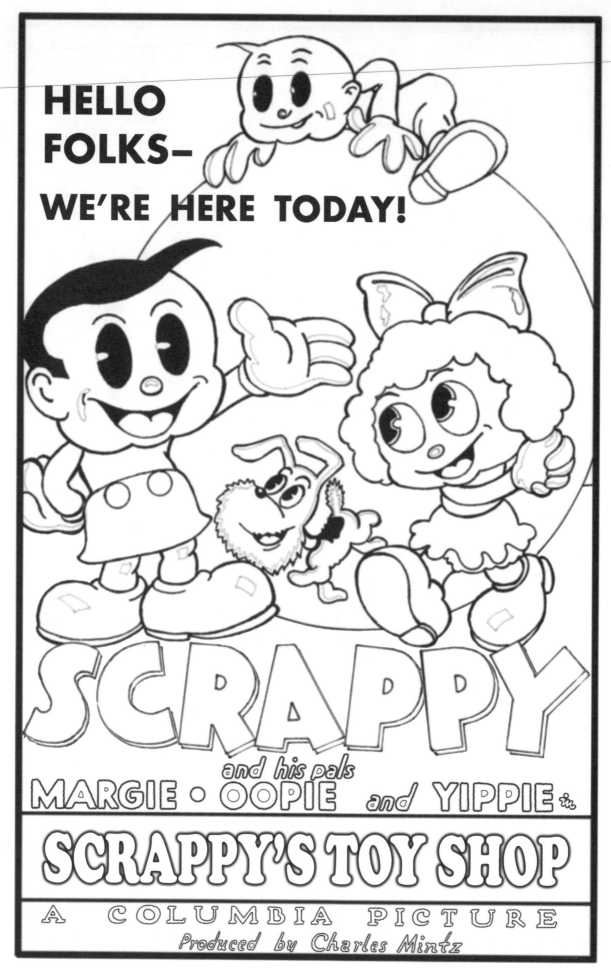

44

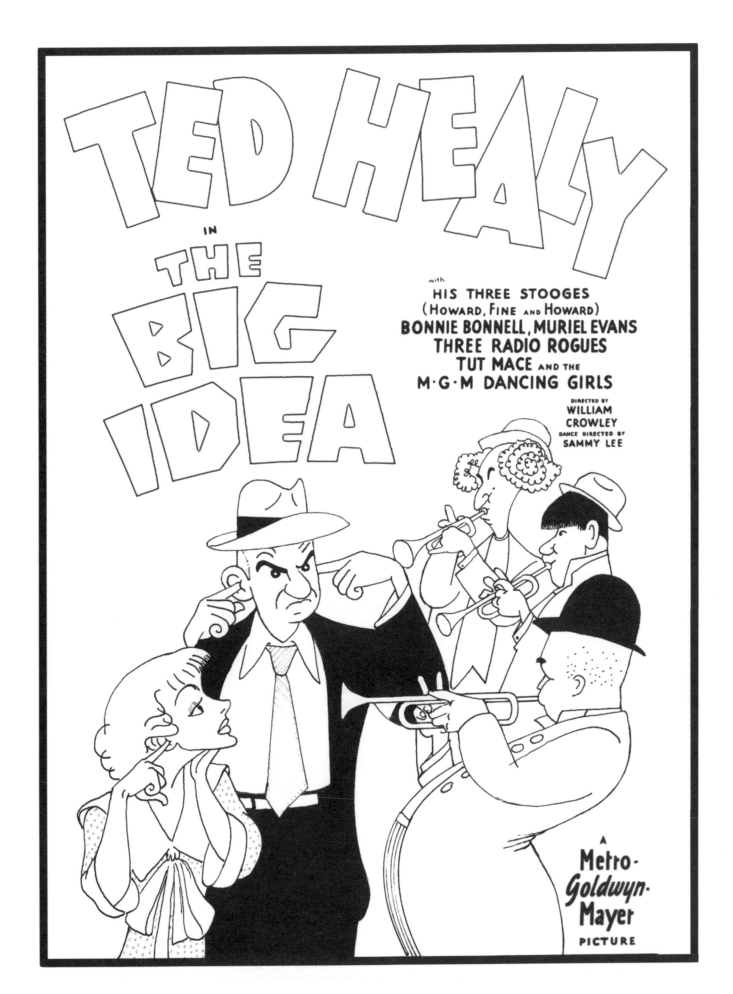

45

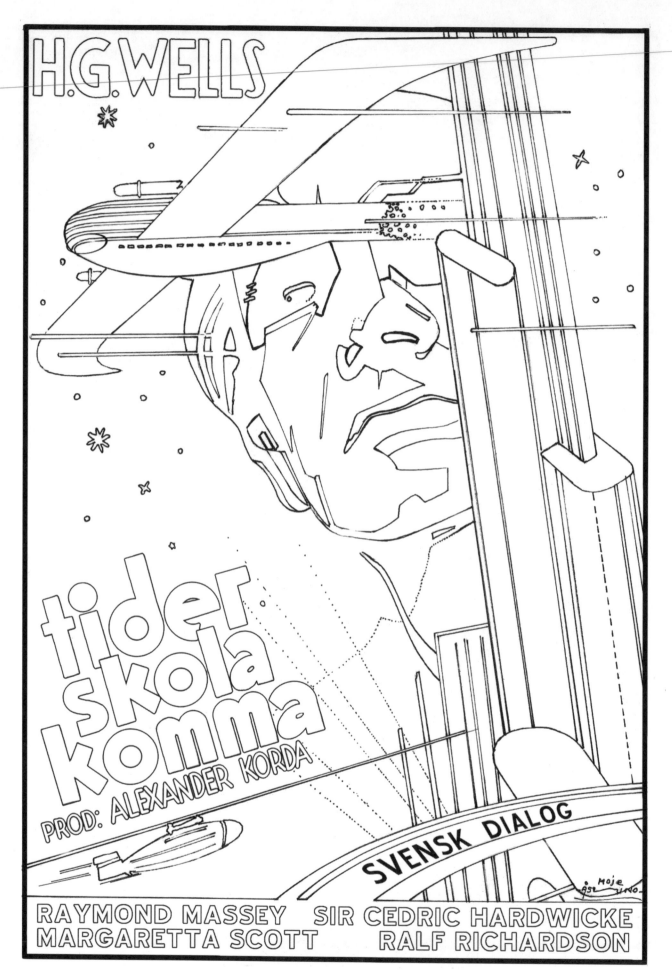

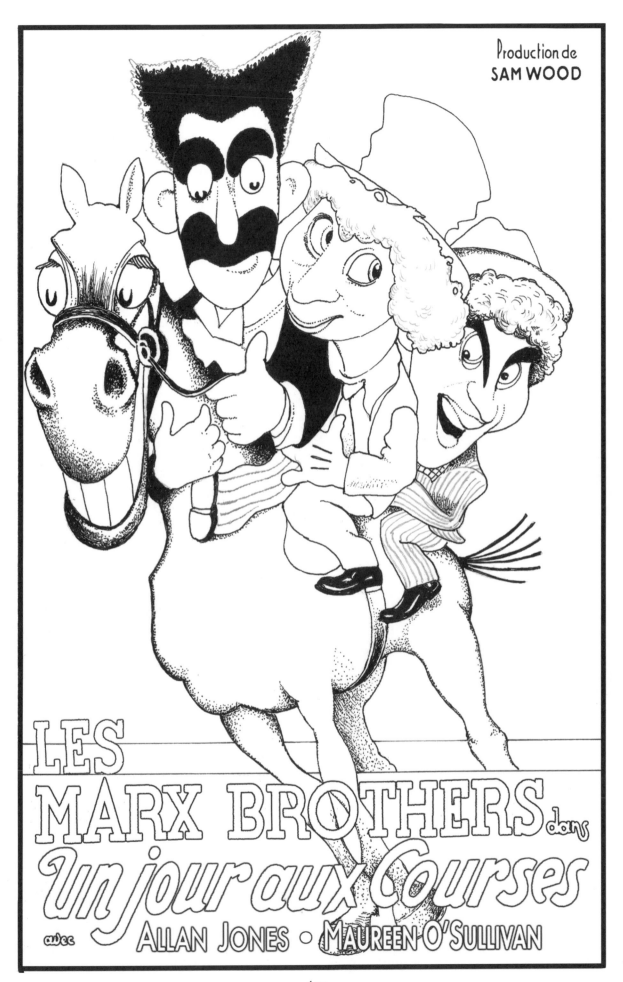

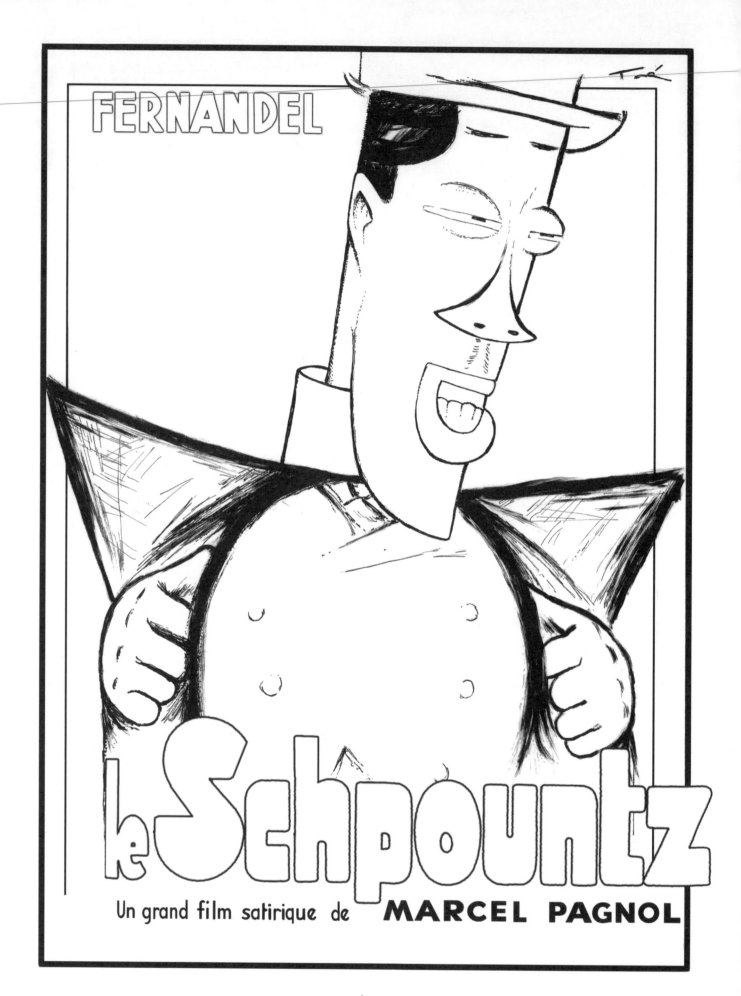

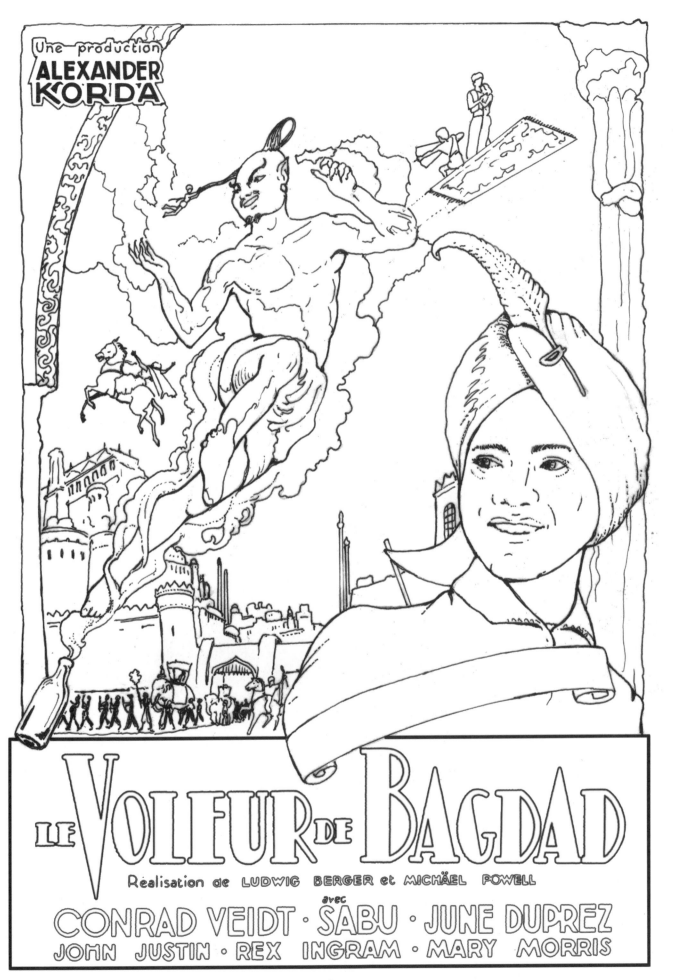

PATHÉ FRÈRES